ALL OUR YESTERDAYS

*Father Browne's Photographs of Children
and Their Favourite Poems*

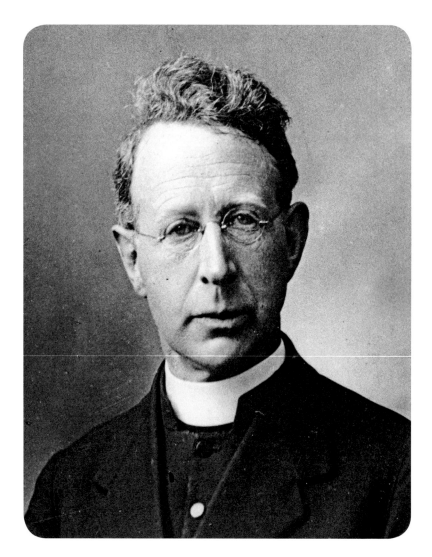

Father Frank Browne SJ

ALL OUR YESTERDAYS

*Father Browne's Photographs of Children
and Their Favourite Poems*

Edited by
E. E. O'Donnell SJ

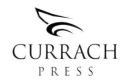

CURRACH PRESS

First published in 2007 by
CURRACH PRESS
55A Spruce Avenue, Stillorgan Industrial Park,
Blackrock, Co. Dublin

www.currach.ie

1 3 5 7 9 10 8 6 4 2

Cover by Bluett

Printed by Estudios Gráficos Zure, Bilbao, Spain

ISBN 978-1-85607-952-5

Father Browne prints are available from Davison & Associates,
69B Heather Road, Sandyford Industrial Estate, Dublin 18.

Contents

Introduction

Father Browne needs no introduction to people who have perused the nineteen books of his photographs that have been published over the past two decades. New readers, however, might like to glance at a potted biography of the man here and now before moving on to the fuller biography, *A Life in Pictures*, which was published by Wolfhound Press in 1994.

Born in Cork in 1880, Frank Browne was educated by the Christian Brothers in that city, by the Bower Convent nuns in Athlone, by the Jesuits at Belvedere College in Dubin and by the Vincentians at Castleknock College, also in Dublin. In 1897 he toured Europe with his brother and his new camera – a present from his uncle, Robert Browne, Bishop of Cloyne.

He joined the Jesuits that autumn and after two years' noviceship spent three years studying humanities at UCD (then part of the Royal University) with fellow-Belvederian, James Joyce. Three more years (1903–6) were spent in Italy studying philosophy. Then Frank taught at Belvedere for five years. In 1911 he began his four-year course of theology at Milltown Park, Dublin. It was during his second year there that Uncle Robert sent him the present of a lifetime: a first-class ticket for the first two legs of the *Titanic*'s maiden voyage – Southampton to Cherbourg, Cherbourg to Queenstown (Cobh).

In 1915 he was ordained a priest and two years later became a chaplain to the Irish Guards in France and Flanders. Described by his commanding officer, Colonel (later Field Marshal Lord) Alexander as 'The bravest man I ever met', he was awarded the British Military Cross and Bar and both the Belgian and the Fench *Croix de Guerre*.

Demobilised in 1920, he was appointed Superior of Gardiner Street church in Dublin but had to spend two years of his term of office (1924–5) recovering from the mustard-gassing of 1918. He went to Australia via South Africa and returned via Ceylon (now Sri Lanka). In 1929 he was appointed to the Jesuit Retreats and Missions Staff, a post he occupied until his death in 1960. His work brought him – and his camera – to practically every parish in Ireland and to many in England, Scotland and Wales

as well. During these thirty years his home base was at Emo, County Laois, in the midlands of Ireland, where he took several of the photographs selected for this book.

By the time of his death he had accumulated 42,000 negatives, mostly on nitrate stock. This cache was unearthed in 1985 and, thanks to the generosity of Allied Irish Bank, transferred to safety film. Exhibitions of his work have now been shown in over a hundred locations world-wide, ranging from the Georges Pompidou Centre in Paris (1996) to the Titanic Museum in Bronson, Missouri (2007). As curator of the Father Browne Collection, I have been invited to address audiences as far apart as Boston and Melbourne, Tokyo and Memphis, Canberra and San Diego, Crossmolina and Skibbereen. My hope is that the photographs in this book will add a little more to his already illustrious reputation as a world-class artist.

Now for a few words about this book itself. The poems and rhymes were chosen with Father Browne's photographs in mind – although the reverse of this is true too. The poems begin with simple ones for pre-school children and, generally speaking, work their way up through primary and secondary school levels. The Irish Junior Certificate and Leaving Certificate are covered by the later poems, the criterion, as ever, being that they are liked and remembered by many people across the English-speaking world. Photographs from England, Sri Lanka, Egypt and Australia underline the international interest.

Several poems of Father Gerard Manley Hopkins SJ are included: the poet and the photographer lie buried in the same grave at Glasnevin Cemetery, Dublin. Another poet, Rudyard Kipling, is shown in one of the later pages here: he was a friend of the photographer due to his having had a son in the Irish Guards. His two-volume history of the regiment makes frequent reference to the chaplain.

Three of these pictures could have longer captions. The one for the Mother and Child Scheme booklet was taken at the request of Noël Browne, the Minister for Health (no relative) whose health initiative went on to bring down the inter-party government of Ireland in 1951.

The photograph of the child playing with his spinning-top on the deck of the *Titanic* shows six-year-old Robert Spedden of New York being watched by his father Frederic. Both father and son were rescued by the *Carpathia* but some years later the boy was knocked down and killed by a car and his father drowned in a swimming-pool.

The photograph of the School of Art in Dublin won a medal. In fact, Father Browne won many awards for his photographs during his lifetime, including the gold medal of the Irish Photographic Society. Not long ago the same Society presented me with the same award, the first non-photographer to be so honoured. I would like to take this opportunity of thanking the Society publicly for its continued interest in Father Browne's work.

Monday's Child

Anon

Monday's child is fair of face,
Tuesday's child is full of grace,
Wednesday's child is full of woe,
Thursday's child has far to go.
Friday's child is loving and giving,
Saturday's child works hard for a living,
But the child born on the Sabbath Day,
Is fair and wise and good and gay.

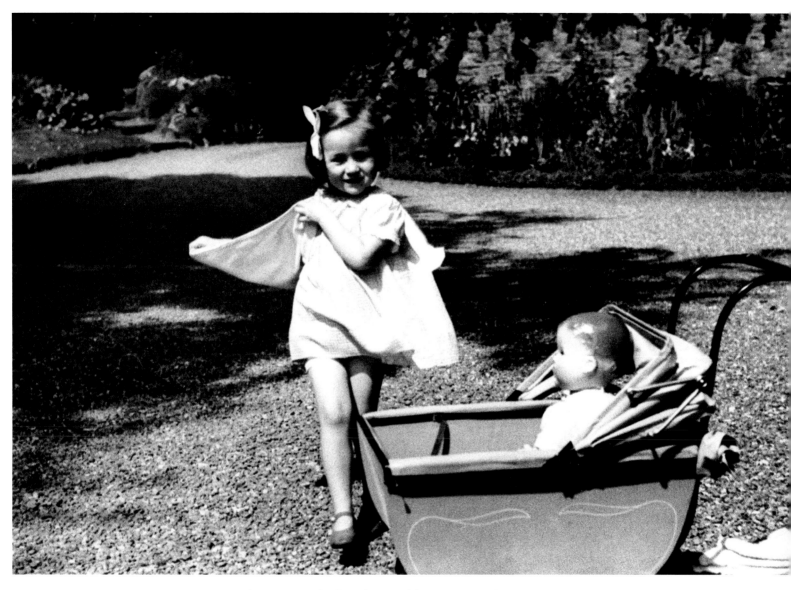

Jennifer Cronin of 'The Glen', Cobh, County Cork (1940).

The Cat and the Fiddle

Anon

Hey diddle diddle, the cat and the fiddle,
The cow jumped over the moon,
The little dog laughed to see such sport,
And the dish ran away with the spoon.

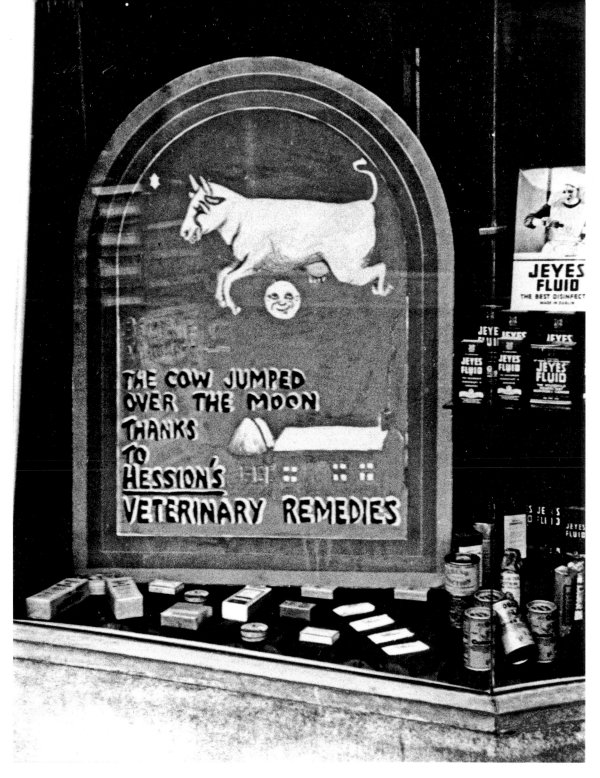

Veterinary remedies on sale at Hession's of Loughrea, County Galway (1940).

A Few Rules for Beginners

Katherine Mansfield

Babies must not eat the coal
And they must not make grimaces,
Nor in party dresses roll
And must never black their faces.

They must learn that pointing's rude,
They must sit quite still at table,
And must always eat the food
Put before them – if they're able.

If they fall, they must not cry,
Though it's known how painful this is;
No – there's always Mother by
Who will comfort them with kisses.

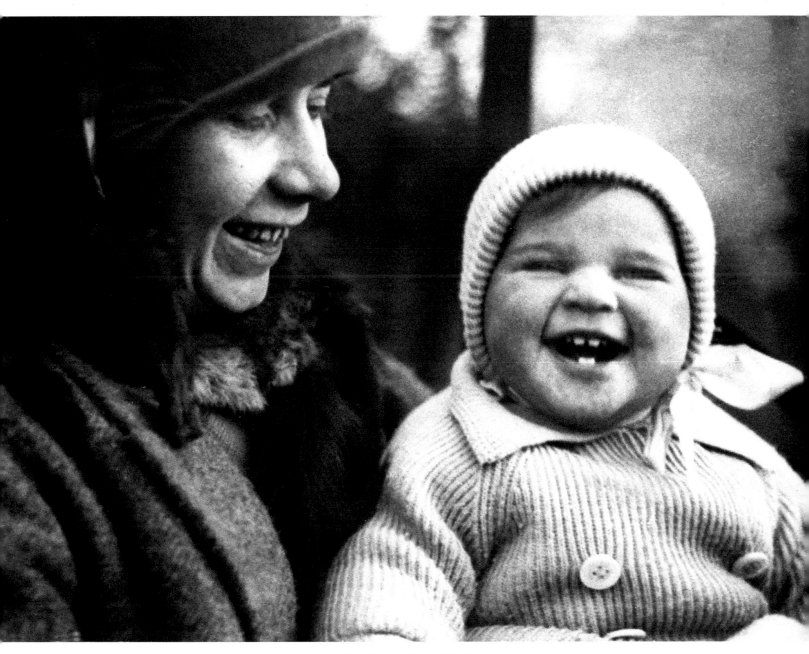

Happiness, Cork (1938).

An Apple a Day

Anon

An apple a day
Keeps the doctor away.
Apple in the morning
Doctor's warning.
Roast apple at night
Starves the doctor outright.
Eat an apple going to bed
Knock the doctor on the head.
Three each day, seven days a week
Ruddy apple, ruddy cheek.

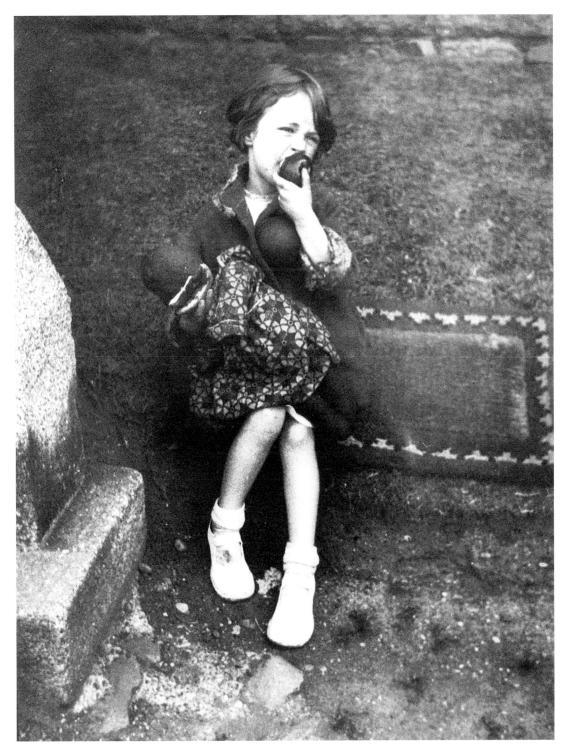

'Eve', Rathkeale, County Limerick (1933).

Two Little Kittens

Anon

Two little kittens, one stormy night,
Began to quarrel, and then to fight;
One had a mouse, the other had none,
And that's the way the quarrel begun.

'I'll have that mouse,' said the biggest cat;
'You'll have that mouse? We'll see about that!'
'I will have that mouse,' said the eldest son;
'You shan't have the mouse,' said the little one.

I told you before 'twas a stormy night
When these two little kittens began to fight;
The old woman seized her sweeping broom,
And swept the two kittens right out of the room.

The ground was covered with frost and snow,
And the two little kittens had nowhere to go;
So they laid them down on the mat at the door,
While the old woman finished sweeping the floor.

Then they crept in, as quiet as mice,
All wet with the snow, and as cold as ice,
For they found it was better, that stormy night,
To lie down and sleep than to quarrel and fight.

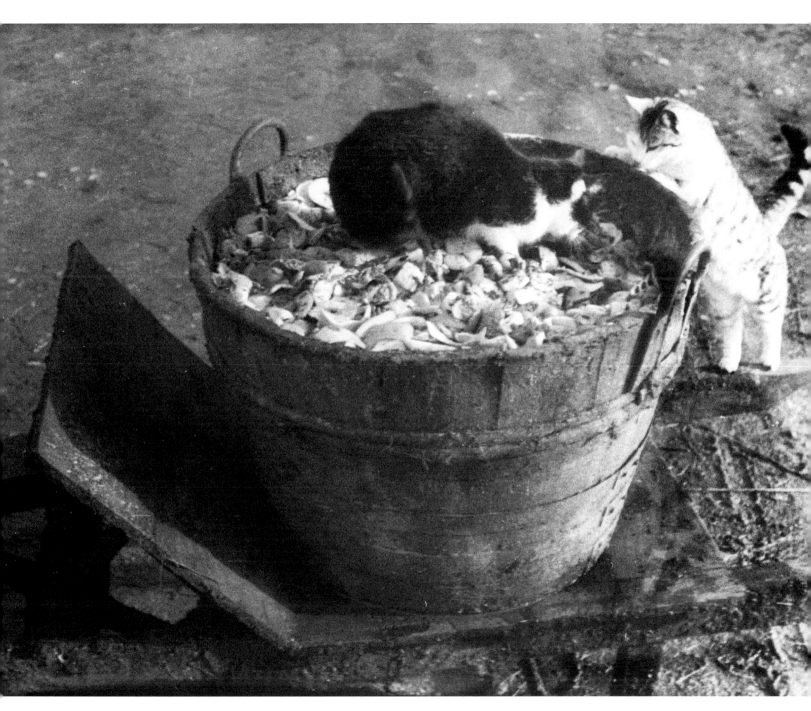

Kittens at Emo, County Laois (1933).

Little Hen

Anon

I had a little hen, the prettiest ever seen,
She washed up the dishes and kept the house clean.
She went to the mill to fetch us some flour,
And always got home in less than an hour.
She baked me my bread, she brewed me my ale,
She sat by the fire and told a fine tale!

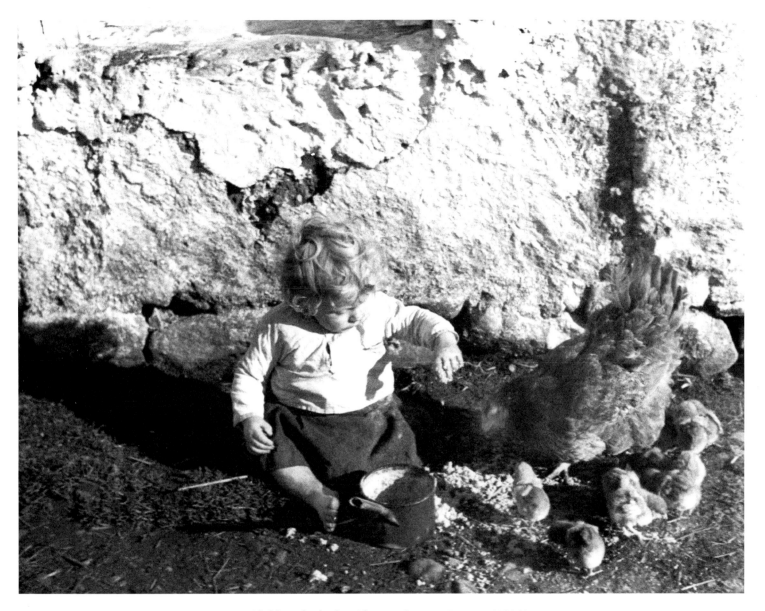

Child with chicks, Cloone, County Leitrim (1933).

I'm Forever Blowing Bubbles

Jaan Kenbroven and John William Kellete

I'm forever blowing bubbles,
Pretty bubbles in the air,
They fly so high,
Nearly reach the sky,
Then like my dreams
They fade and die.
Fortune's always hiding,
I've looked everywhere,
I'm forever blowing bubbles,
Pretty bubbles in the air.

I'm dreaming dreams,
I'm scheming schemes, I'm building castles high.
They're born anew, their days are few,
Just like a sweet butterfly.
And as the daylight is dawning,
They come again in the morning!

When shadows creep, when I'm asleep
To lands of hope I stray,
Then at daybreak, when I awake,
My bluebird flutters away,
'Happiness, you seem so near me
Happiness come forth and cheer me!'

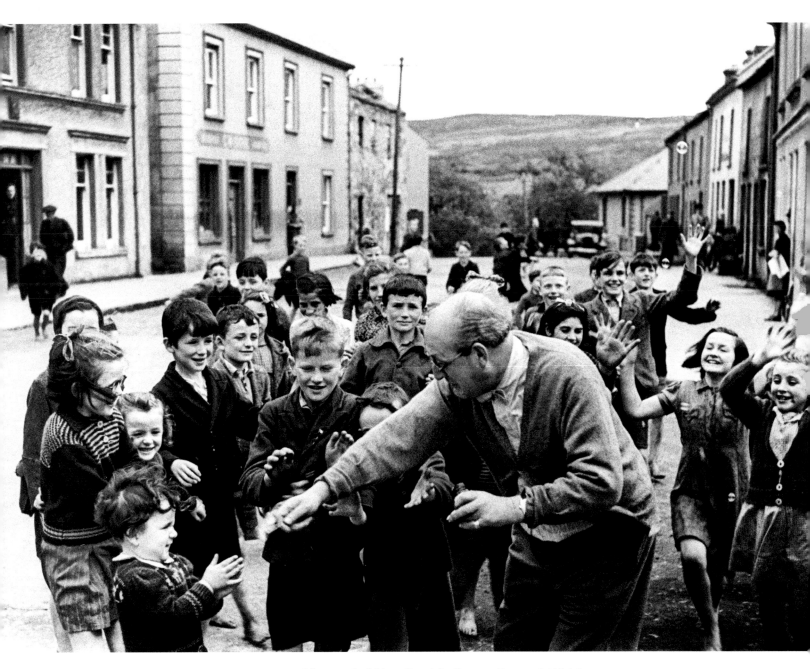

Mr F. R. Kitts blowing bubbles, Carrick, County Donegal (1946).

Báidín Fheilimí

Ní fios cé a chum

Báidín Fheilimí d'imigh go Gabhla,
Báidín Fheilimí's, Feilimí ann
Báidín Fheilimí d'imigh go Gabhla,
Báidín Fheilimí's, Feilimí ann

Curfá

Báidín bídeach, báidín beosach,
Báidín bóideach, báidín Fheilimí.
Báidín díreach, báidín deontach
Báidín Fheilimí's, Feilimí ann

Báidín Fheilimí d'imigh go Toraigh,
Báidín Fheilimí's, Feilimí ann
Báidín Fheilimí d'imigh go Toraigh,
Báidín Fheilimí's, Feilimí ann

Curfá

Báidín Fheilimí briseadh i d'Toraigh,
Báidín Fheilimí's, Feilimí ann
Báidín Fheilimí briseadh i d'Toraigh,
Báidín Fheilimí's, Feilimí ann

Curfá

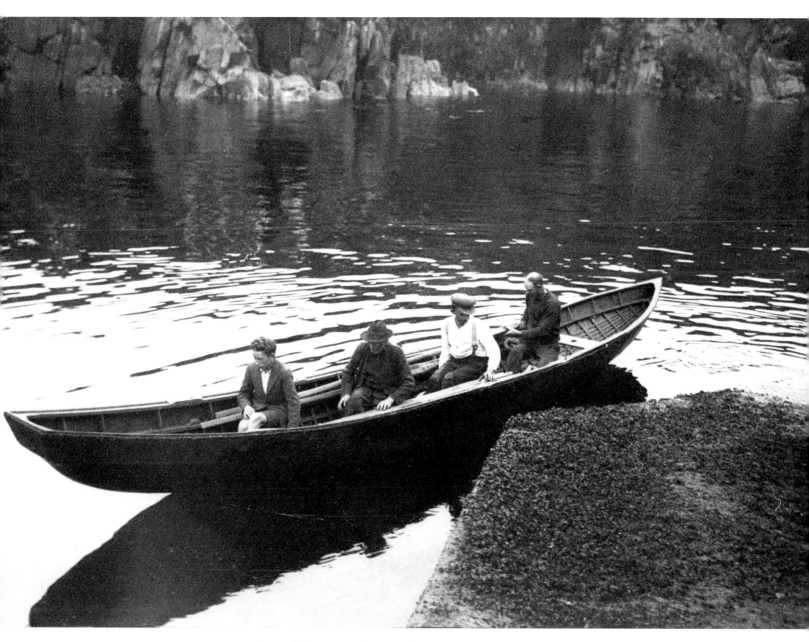

Naomhóg at Brandon Creek, County Kerry (1932).

A Memory

William Allingham

Four ducks on a pond,
A grass-bank beyond,
A blue sky of spring,
White clouds on the wing;
What a little thing
To remember for years –
To remember with tears!

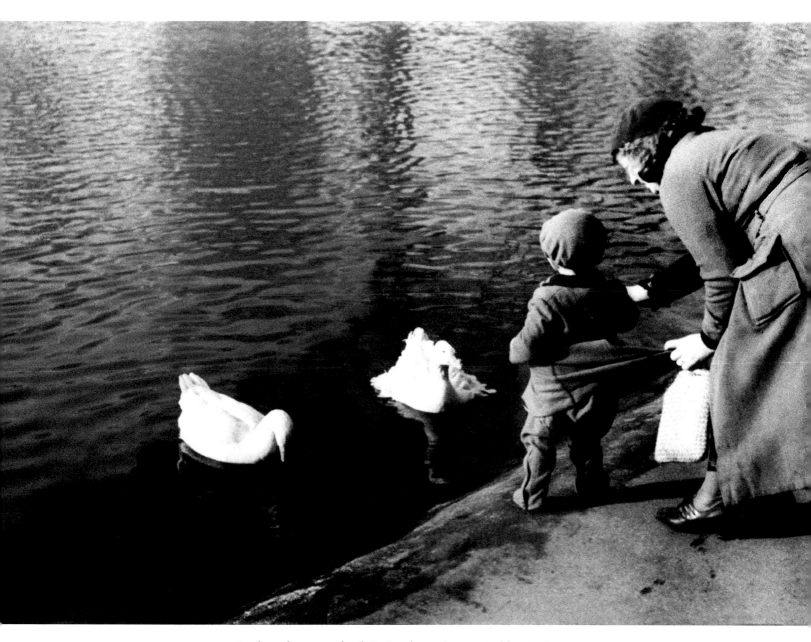

Feeding the water-fowl, St Stephen's Green, Dublin (1938).

Choosing Shoes

Ffrida Wolfe

New shoes, new shoes,
Red and pink and blue shoes.
Tell me, what would you choose,
If they'd let us buy?

Buckle shoes, bow shoes,
Pretty pointy-toe shoes,
Strappy, cappy low shoes;
Let's have some to try.

Bright shoes, white shoes,
Dandy-dance-by-night shoes,
Perhaps-a-little-tight shoes,
Like some? So would I.

BUT
Flat shoes, fat shoes,
Stump-along-like-that shoes,
Wipe-them-on-the-mat shoes,
That's the sort they'll buy.

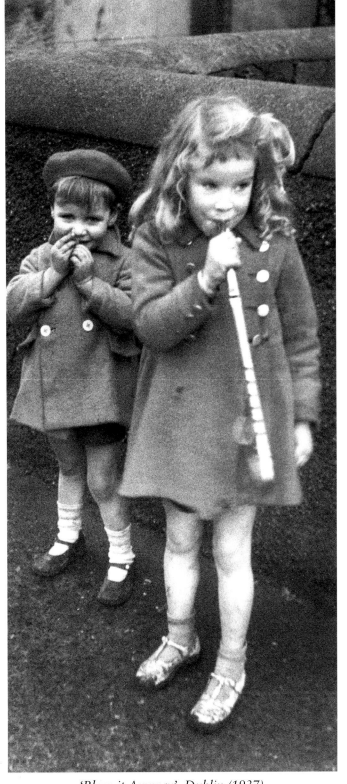

'Blow it Anyway', Dublin (1937).

The Fairies

William Allingham

Up the airy mountain
 Down the rushy glen,
We daren't go a-hunting,
 For fear of little men;
Wee folk, good folk,
 Trooping all together;
Green jacket, red cap,
 And white owl's feather.

Down along the rocky shore
 Some make their home,
They live on crispy pancakes
 Of yellow tide-foam;
Some in the reeds
 Of the black mountain-lake,
With frogs for their watch-dogs,
 All night awake.

High on the hill-top
 The old King sits;
He is now so old and gray
 He's nigh lost his wits.
With a bridge of white mist
 Columbkill he crosses,
On his stately journeys
 From Slieveleague to Rosses;
Or going up with music,
 On cold starry nights,
To sup with the Queen,
 Of the gay Northern Lights.

They stole little Bridget
 For seven years long;
When she came down again
 Her friends were all gone.
They took her lightly back
 Between the night and morrow;
They thought she was fast asleep,
 But she was dead with sorrow.
They have kept her ever since
 Deep within the lake,
On a bed of flag leaves,
 Watching till she wake.

By the craggy hill-side,
 Through the mosses bare,
They have planted thorn trees
 For pleasure here and there.
Is any man so daring
 As dig them up in spite?
He shall find the thornies set
 In his bed at night.

Up the airy mountain
 Down the rushy glen,
We daren't go a-hunting,
 For fear of little men;
Wee folk, good folk,
 Trooping all together;
Green jacket, red cap,
 And white owl's feather.

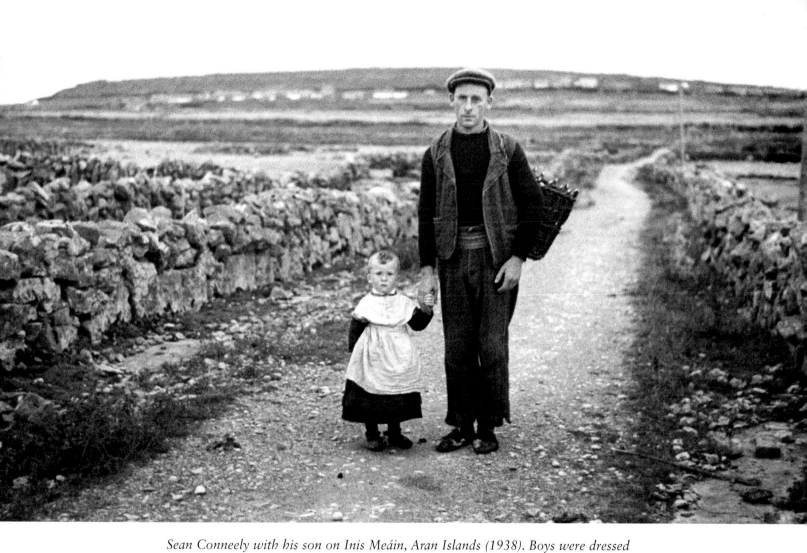

Sean Conneely with his son on Inis Meáin, Aran Islands (1938). Boys were dressed as girls for fear they would be snatched by the fairies.

The Swing

Robert Louis Stevenson

How do you like to go up in a swing,
 Up in the air so blue?
Oh, I do think it the pleasantest thing
 Ever a child can do!

Up in the air and over the wall,
 Till I can see so wide,
River and trees and cattle and all
 Over the countryside –

Till I look down on the garden green,
 Down on the roof so brown –
Up in the air I go flying again,
 Up in the air and down!

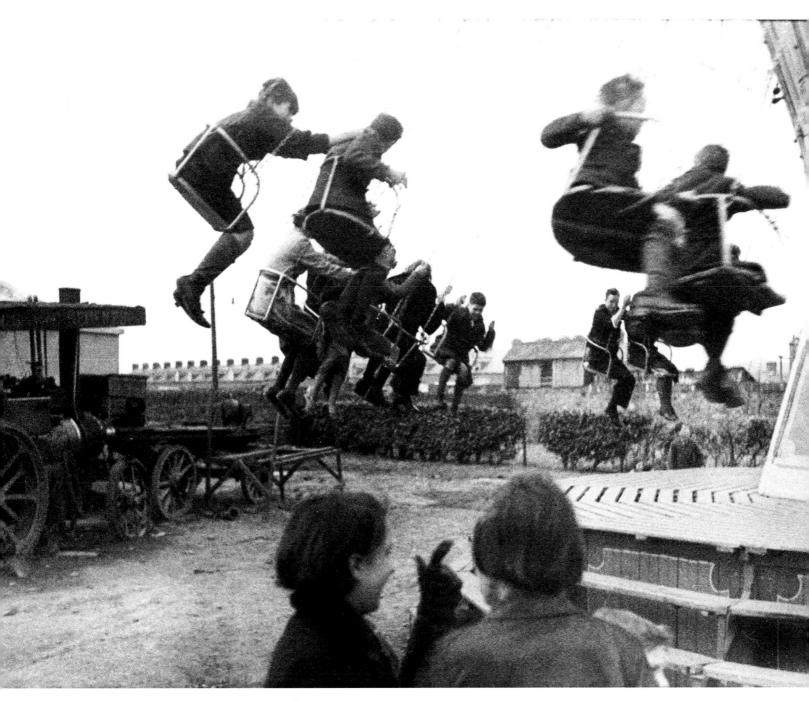

All the fun of the fair at Ardee, County Louth (1936).

My Shadow

Robert Louis Stevenson

I have a little shadow that goes in and out with me,
And what can be the use of him is more than I can see.
He is very, very like me from the heels up to the head;
And I see him jump before me, when I jump into my bed.

The funniest thing about him is the way he likes to grow –
Not at all like proper children, which is always very slow;
For he sometimes shoots up taller like an india-rubber ball,
And he sometimes goes so little that there's none of him at all.

He hasn't got a notion of how children ought to play,
And can only make a fool of me in every sort of way.
He stays so close behind me, he's a coward you can see;
I'd think shame to stick to nursie as that shadow sticks to me!

One morning, very early, before the sun was up,
I rose and found the shining dew on every buttercup;
But my lazy little shadow, like an arrant sleepy-head,
Had stayed at home behind me and was fast asleep in bed.

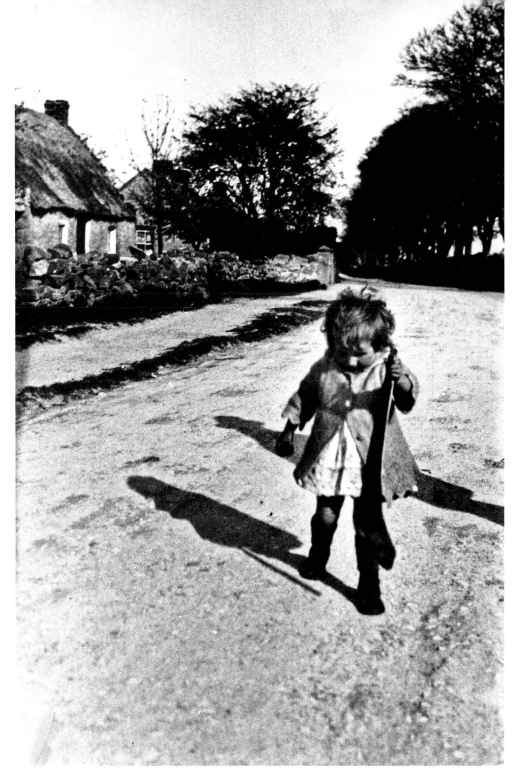

'The Victor', Mungret, County Limerick (1925).

Pippa Passes

Robert Browning

The year's at the spring,
And day's at the morn;
Morning's at seven;
The hill-side's dew-pearled;
The lark's on the wing;
The snail's on the thorn;
God's in his Heaven –
All's right with the world!

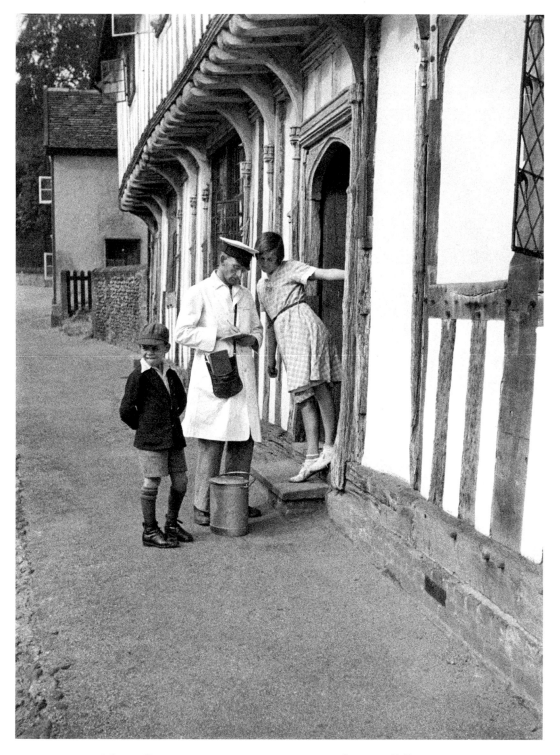

The Milkman, Mr T. W. Norman, at Lavenham, Suffolk (1933).

Nature

Emily Dickinson

Perhaps you'd like to buy a flower?
But I could never sell.
If you would like to borrow
Until the daffodil

Unties her yellow bonnet
Beneath the village door,
Until the bees, from clover rows
Their hock and sherry draw,

Why, I will lend until just then,
But not an hour more!

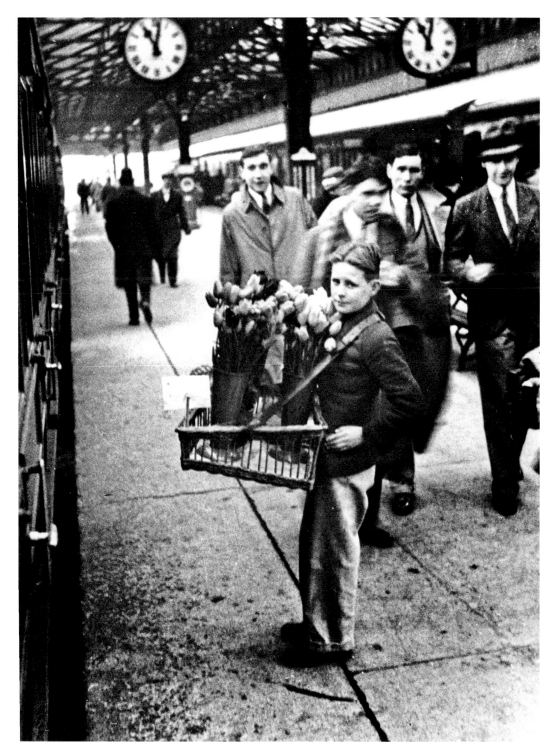

Flower seller at Great Victoria Street Station, Belfast (1933).

The Blind Man and the Elephant

John Godfrey Saxe

It was six men of Hindustan
To learning much inclined,
Who went to see the Elephant – (Though all of them
 were blind),
That each by observation – Might satisfy his mind.

The First approached the Elephant,
And happening to fall
Against his broad and sturdy side, – At once began
 to bawl:
'God bless me! but the Elephant – Is very like a
 wall!'

The Second, feeling of the tusk,
Cried, 'Ho! what have we here?
So very round and smooth and sharp? – To me 'Tis
 mighty clear
This wonder of an Elephant – Is very like a spear!'

The Third approached the animal,
And happening to take
The squirming trunk within his hands, – Thus boldly
 up and spake:
'I see,' quoth he, 'the Elephant – Is very like a snake!'

The Fourth reached out an eager hand,
And felt about the knee.
'What most this wondrous beast is like – Is mighty
 plain,' quoth he:
''Tis clear enough the Elephant – Is very like a tree!'

The Fifth who chanced to touch the ear,
Said: 'E'en the blindest man
Can tell what this resembles most; – Deny the fact
 who can,
This marvel of an Elephant – Is very like a fan!'

The Sixth no sooner had begun
About the beast to grope,
Than, seizing on the swinging tail – That fell within
 his scope,
'I see,' quoth he, 'the Elephant – Is very like a rope!'

And so these men of Hindustan
Disputed loud and long,
Each in his own opinion – Exceeding stiff and
 strong,
Though each was partly in the right – And all were
 in the wrong!

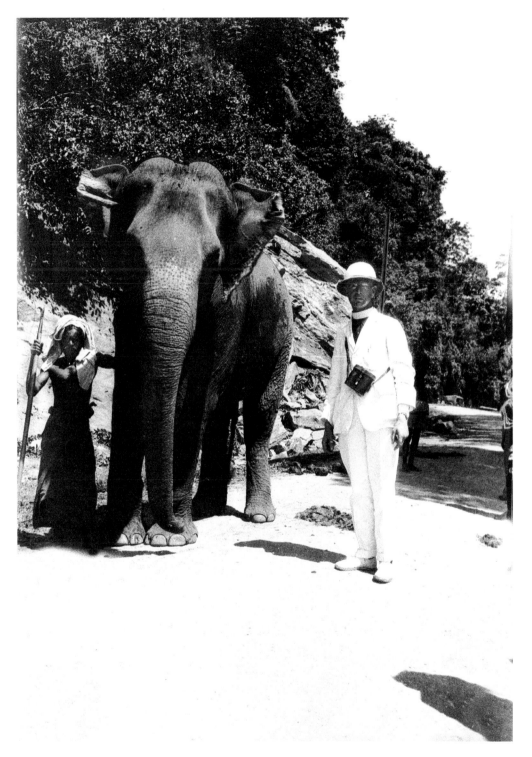

Father Browne with an elephant and its mahout, Kandy, Sri Lanka (1925).

Kindness To Animals

Anon

Little children, never give
Pain to things that feel and live;
Let the gentle robin come
For the crumbs you save at home,
As his meat you throw along...
He'll repay you with a song;
Never hurt the timid hare
Peeping from her green grass lair,
Let her come and sport and play
On the lawn at close of day;
The little lark goes soaring high
To the bright windows of the sky,
Singing as if 'twere always spring,
And fluttering on an untired wing.
Oh! let him sing his happy song,
Nor do these gentle creatures wrong.

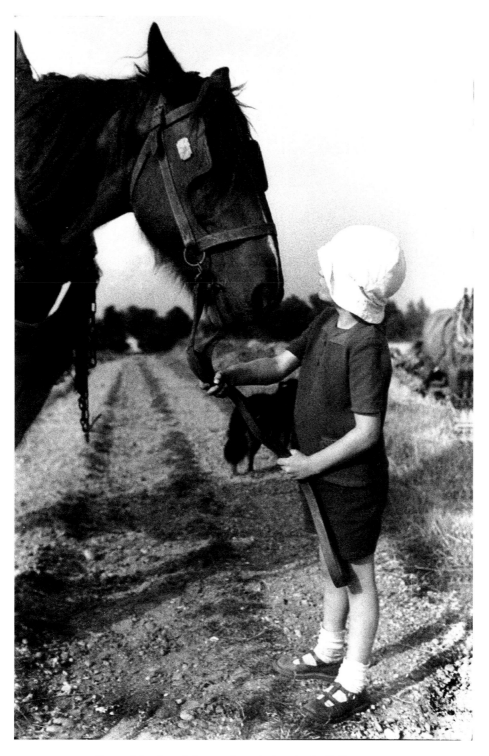

Boy with plough horse, Burgh Castle, Suffolk (1933).

A Boy's Song

James Hogg

Where the pools are bright and deep,
Where the grey trout lies asleep,
Up the river and over the lea,
That's the way for Billy and me.

Where the blackbird sings the latest,
Where the hawthorn blooms the sweetest,
Where the nestlings chirp and flee,
That's the way for Billy and me.

Where the mowers mow the cleanest,
Where the hay lies thick and greenest,
There to track the homeward bee,
That's the way for Billy and me.

Where the hazel bank is steepest,
Where the shadow falls the deepest,
Where the clustering nuts fall free,
That's the way for Billy and me.

Why the boys should drive away
Little sweet maidens from the play,
Or love to banter and fight so well,
That's the thing I never could tell.

But this I know, I love to play
Through the meadow, among the hay;
Up the water and over the lea,
That's the way for Billy and me.

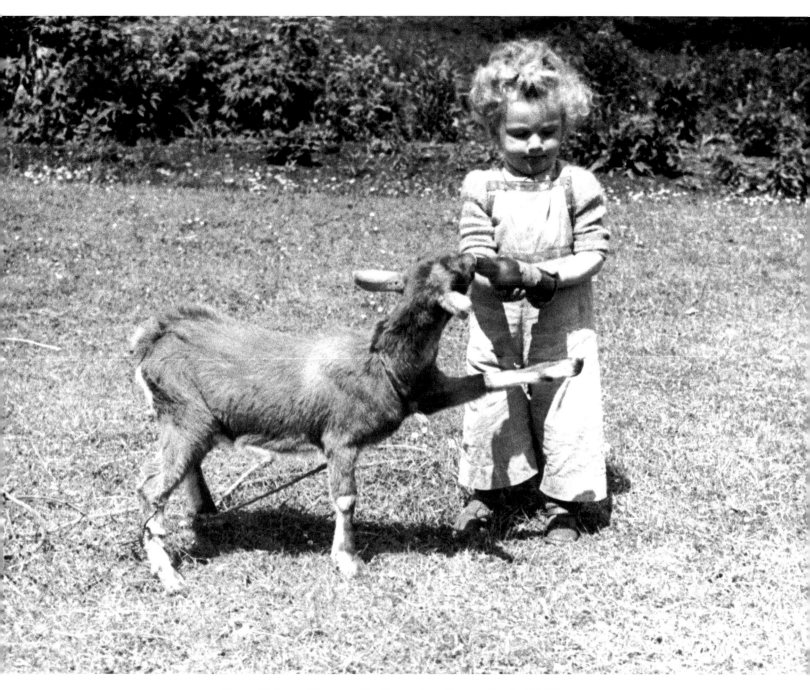

Barry Kehoe with goat, Coolbanagher, County Laois (1946).

Frolic

Æ (George William Russell)

The children were shouting together
And racing along the sands,
A glimmer of dancing shadows,
A dovelike flutter of hands.

The stars were shouting in heaven,
The sun was chasing the moon:
The game was the same as the children's,
They danced to the self-same tune.

The whole of the world was merry,
One joy from the vale to the height,
Where the blue woods of twilight encircled
The lovely lawns of the light.

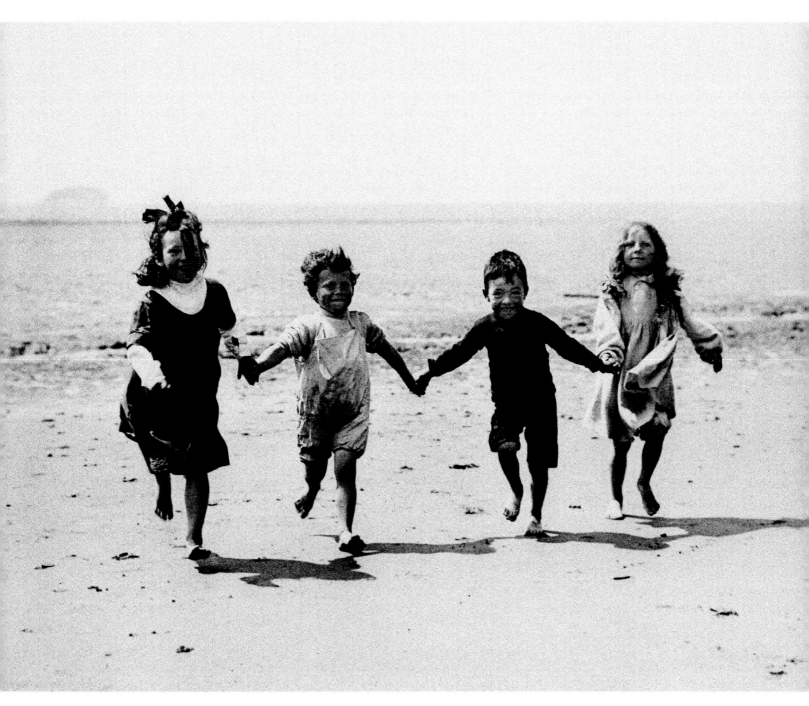

On the beach, Valentia Island, County Kerry (1909).

Where is Heaven?

William Bliss Carman

Where is Heaven? Is it not
Just a friendly garden plot,
Walled with stone and roofed with sun,
Where the days pass one by one
Not too fast and not too slow,
Looking backward as they go
At the beauties left behind
To transport the pensive mind.

Does not Heaven begin that day
When the eager heart can say,
Surely God is in this place,
I have seen Him face to face
In the loveliness of flowers,
In the service of the showers,
And His voice has talked to me
In the sunlit apple tree.

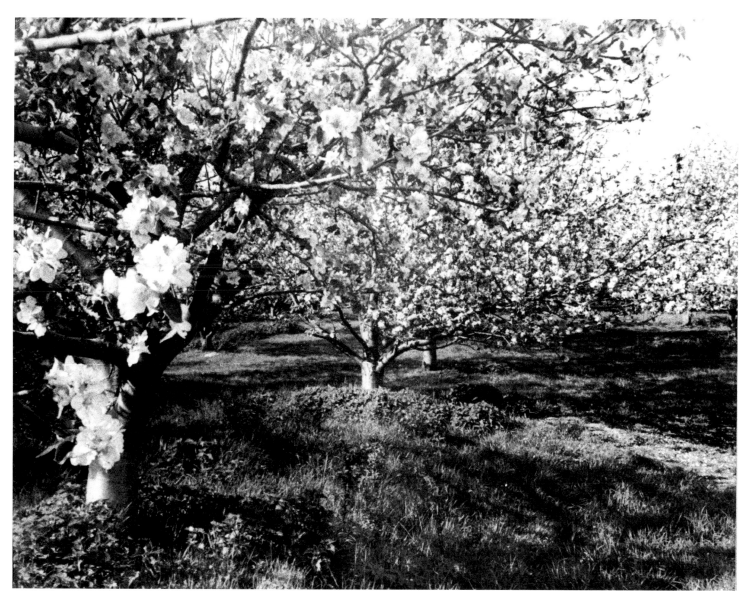

Blossoms at Benburb, County Tyrone (1934).

Snowflake

Henry Wadsworth Longfellow

Out of the bosom of the air,
Out of the cloud-folds of her garments shaken,
Over the woodlands brown and bare,
Over the harvest-fields forsaken,
Silent and soft and slow
Descends the snow.

Even as our cloudy fancies take
Suddenly shape in some divine expression,
Even as the troubled heart doth make
In the white countenance confession,
The troubled sky reveals
The grief it feels.

This is the poem of the air,
Slowly in silent syllables recorded;
This is the secret of despair,
Long in its cloudy bosom hoarded,
Now whispered and revealed
To wood and field.

Shadow of train in snow, Inniskeen, County Monaghan (1937).

The Donkey

G. K. Chesterton

When fishes flew and forests walked
And figs grew upon thorn,
Some moment when the moon was blood
Then surely I was born;

With monstrous head and sickening cry
And ears like errant wings,
The devil's walking parody
On all four-footed things.

The tattered outlaw of the earth,
Of ancient crooked will;
Starve, scourge, deride me: I am dumb,
I keep my secret still.

Fools! For I also had my hour;
One far fierce hour and sweet:
There was a shout about my ears,
And palms before my feet.

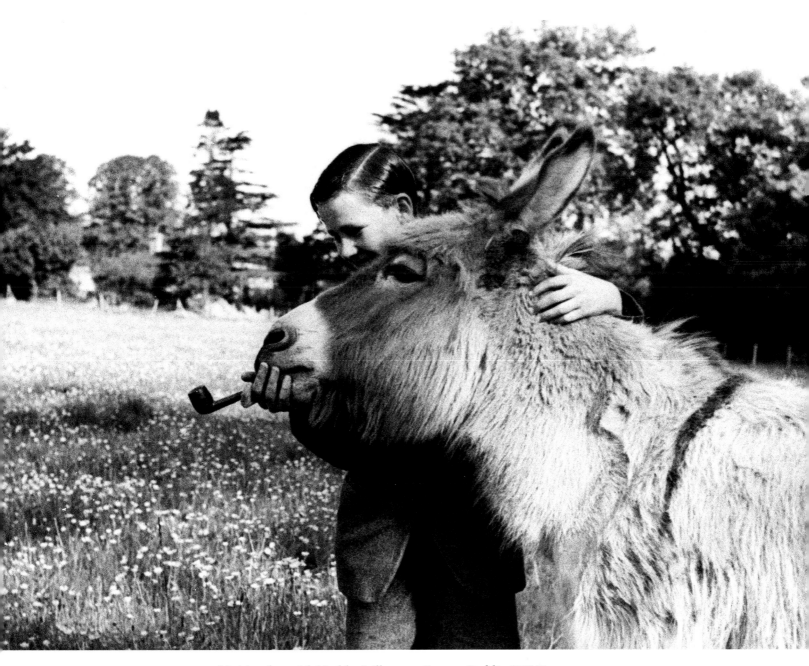

Making fun with Neddy, Stillorgan, County Dublin (1939).

Trees

Joyce Kilmer

I think that I shall never see
A poem lovely as a tree.

A tree whose hungry mouth is prest
Against the sweet earth's flowing breast;

A tree that looks at God all day,
And lifts her leafy arms to pray;

A tree that may in summer wear
A nest of robins in her hair;

Upon whose bosom snow has lain;
Who intimately lives with rain.

Poems are made by fools like me,
But only God can make a tree.

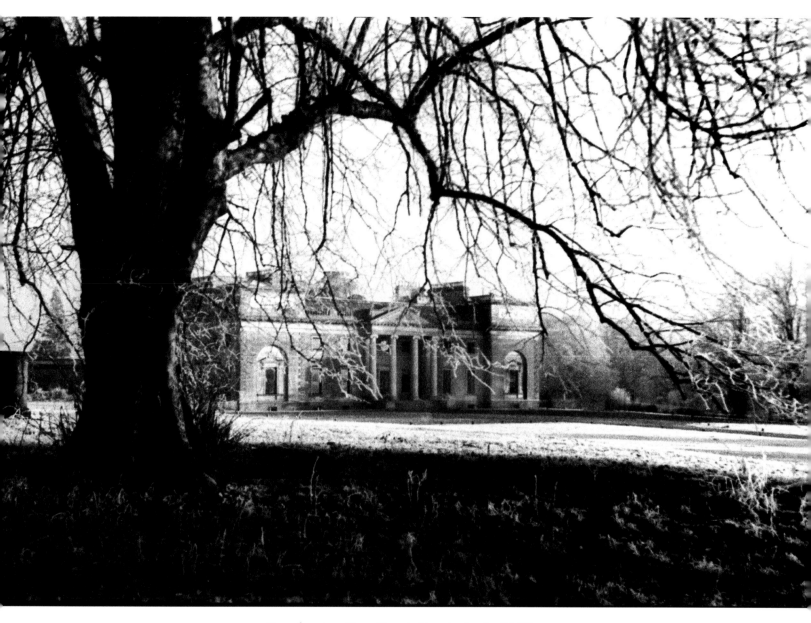

Tree framing, Emo Court, County Laois (1940).

Sheep and Lambs

Katharine Tynan

All in the April morning,
April airs were abroad;
The sheep with their little lambs
Pass'd me by on the road.

The sheep with their little lambs
Pass'd me by on the road;
All in an April evening
I thought on the Lamb of God.

The lambs were weary, and crying
With a weak human cry;
I thought on the Lamb of God
Going meekly to die.

Up in the blue, blue mountains
Dewy pastures are sweet:
Rest for the little bodies,
Rest for the little feet.

But for the Lamb of God
Up on the hill-top green;
Only a cross of shame
Two stark crosses between.

All in the April evening,
April airs were abroad;
I saw the sheep with their lambs,
And thought on the Lamb of God.

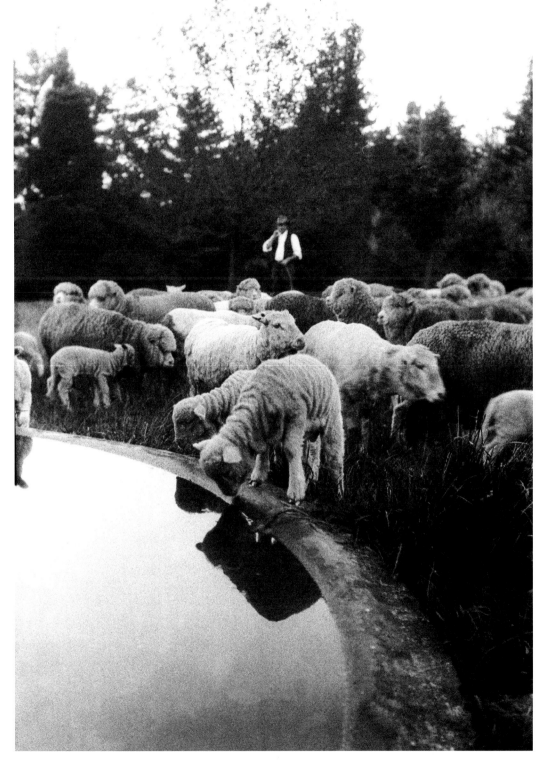

Australian lambs near Kangaroobie, New South Wales (1924).

Song of a Sewing Machine

Constance Woodrow

Oh, the happiest worker of all am I,
As my wheel and my needle so merrily fly;
With a spool full of thread and a heart full of song,
I am ready and willing to work the day long.

Oh, faster and faster my glad wheel flies
When it catches the light in a young maid's eyes;
The dearest and tenderest girlhood dreams
I stitch into gossamer hems and seams.

But slower my wheel and softer my song
When fairy-like fragments are guided along –
I am stitching the dreams most sacred of all
Into dear little gowns and a wee silken shawl.

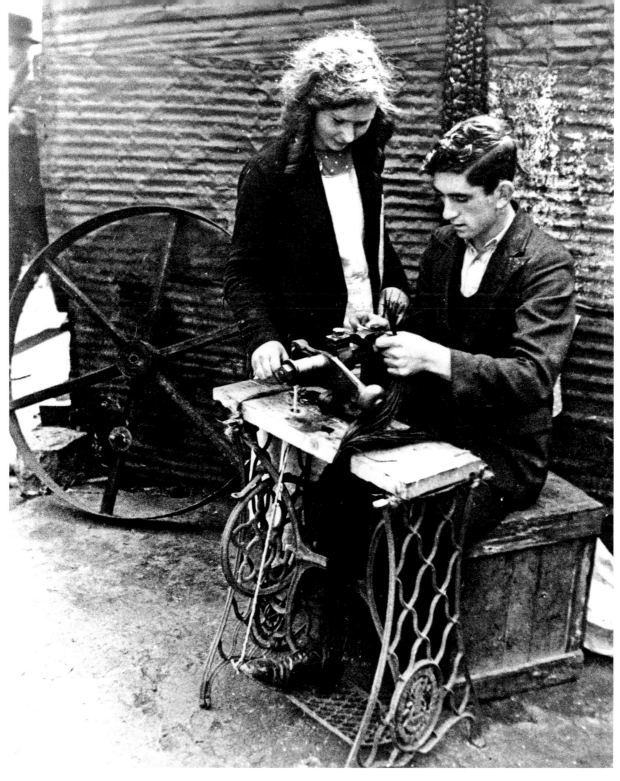

Tagging bootlaces at Long's factory, Pennywell, Limerick (1937).

All Things Bright and Beautiful

Cecil Frances Alexander

All things bright and beautiful,
All creatures great and small,
All things wise and wonderful:
The Lord God made them all.

Each little flower that opens,
Each little bird that sings,
He made their glowing colors,
He made their tiny wings.

The rich man in his castle,
The poor man at his gate,
He made them, high or lowly,
And ordered their estate.

The purple headed mountains,
The river running by,
The sunset and the morning
That brightens up the sky.

The cold wind in the winter,
The pleasant summer sun,
The ripe fruits in the garden,
He made them every one.

The tall trees in the greenwood,
The meadows where we play,
The rushes by the water,
To gather every day.

He gave us eyes to see them,
And lips that we might tell
How great is God Almighty,
Who has made all things well.

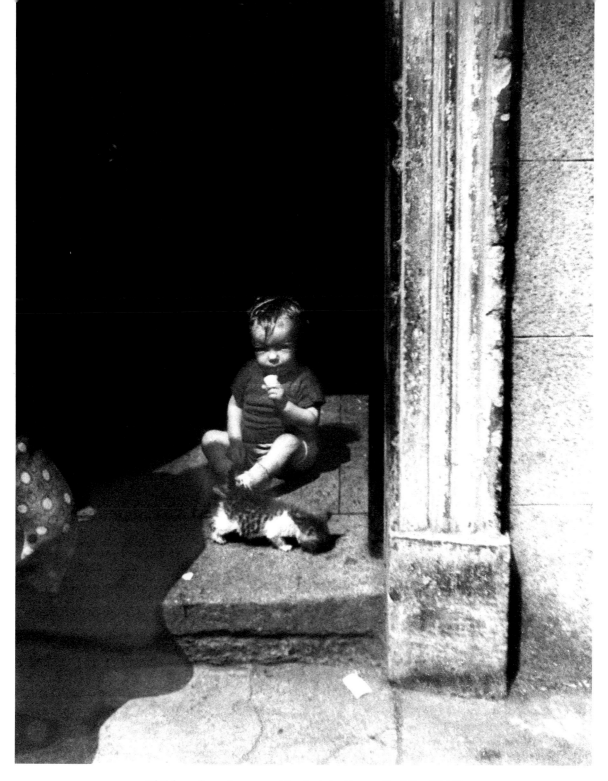

Child at slum doorway, Hardwicke Street, Dublin (1929).

From a Railway Carriage

Robert Louis Stevenson

Faster than fairies, faster than witches,
Bridges and houses, hedges and ditches;
And charging along like troops in a battle,
All through the meadows the horses and cattle:
All of the sights of the hill and the plain
Fly as thick as driving rain;
And ever again, in the wink of an eye,
Painted stations whistle by.

Here is a child who clambers and scrambles,
All by himself and gathering brambles;
Here is a tramp who stands and gazes;
And there is the green for stringing the daisies!
Here is a cart run away in the road
Lumping along with man and load;
And here is a mill and there is a river:
Each a glimpse and gone for ever!

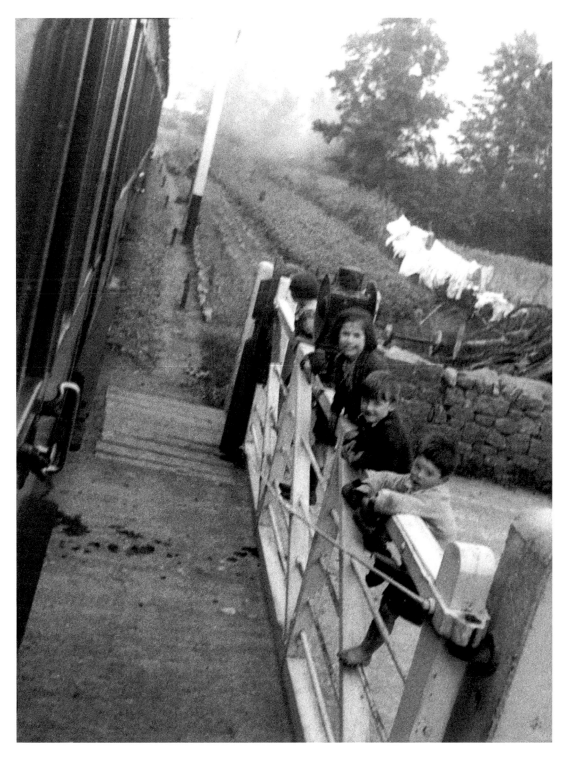

At the level crossing, Wellingtonbridge, County Wexford (1936).

Beidh Aonach Amárach

Traditional

Beidh aonach amárach i gContae an Chláir
Beidh aonach amárach i gContae an Chláir
Beidh aonach amárach i gContae an Chláir
Cé mhaith dom é, ní bheidh mé ann?

A mháithrín, an ligfidh tú chun aonaigh mé?
A mháithrín, an ligfidh tú chun aonaigh mé?
A mháithrín, an ligfidh tú chun aonaigh mé?
A mhuirnín ó ná héiligh é.

Níl tú a deich nó a haon déag fós
Níl tú a deich nó a haon déag fós
Níl tú a deich nó a haon déag fós
Nuair a bheidh tú trí déag bedh tú mór.

B'fhearr liom féin mo ghréasaigh bróg
B'fhearr liom féin mo ghréasaigh bróg
B'fhearr liom féin mo ghréasaigh bróg
Ná oifigeach airm faoi lásaí óir.

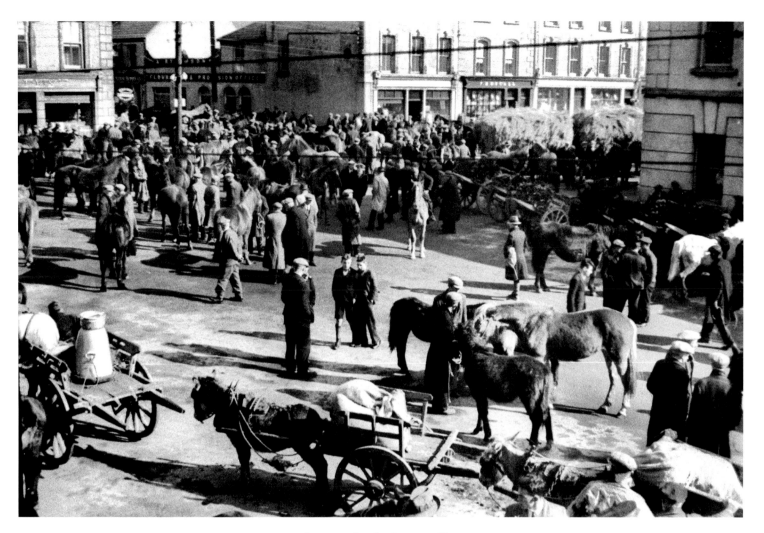

Horse fair at Kilrush, County Clare (1939).

The Village Blacksmith

Henry Wadsworth Longfellow

Under a spreading chestnut-tree
The village smithy stands;
The smith, a mighty man is he,
With large and sinewy hands;
And the muscles of his brawny arms
Are strong as iron bands.

His hair is crisp, and black, and long,
His face is like the tan;
His brow is wet with honest sweat,
He earns whate'er he can,
And looks the whole world in the face,
For he owes not any man.

Week in, week out, from morn till night,
You can hear his bellows blow;
You can hear him swing his heavy sledge,
With measured beat and slow,
Like a sexton ringing the village bell,
When the evening sun is low.

And children coming home from school
Look in at the open door;
They love to see the flaming forge,
And hear the bellows roar,
And catch the burning sparks that fly
Like chaff from a threshing-floor.

He goes on Sunday to the church,
And sits among his boys;
He hears the parson pray and preach,
He hears his daughter's voice,
Singing in the village choir,
And it makes his heart rejoice.

It sounds to him like her mother's voice,
Singing in Paradise!
He needs must think of her once more,
How in the grave she lies;
And with his hard, rough hand he wipes
A tear out of his eyes.

Toiling, – rejoicing, – sorrowing,
Onward through life he goes;
Each morning sees some task begin,
Each evening sees it close;
Something attempted, something done,
Has earned a night's repose.

Thanks, thanks to thee, my worthy friend,
For the lesson thou hast taught!
Thus at the flaming forge of life
Our fortunes must be wrought;
Thus on its sounding anvil shaped
Each burning deed and thought.

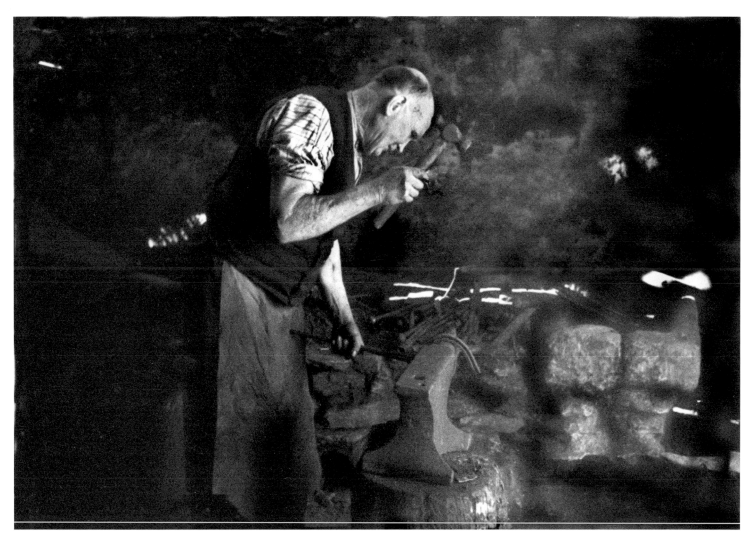

The blacksmith, Johnny Monahan, at his forge near Newbridge, County Kildare (1938).

I Remember, I Remember

Thomas Hood

I remember, I remember
The house where I was born,
The little window where the sun
Came peeping in at morn;
He never came a wink too soon
Nor brought too long a day;
But now, I often wish the night
Had borne my breath away.

I remember, I remember
The roses red and white,
The violets and the lily cups –
Those flowers made of light!
The lilacs where the robin built,
And where my brother set
The laburnum on his birthday –
The tree is living yet!

I remember, I remember
Where I was used to swing,
And thought the air must rush as fresh
To swallows on the wing;
My spirit flew in feathers then
That is so heavy now,
The summer pools could hardly cool
The fever on my brow.

I remember, I remember
The fir-trees dark and high;
I used to think their slender tops
Were close against the sky:
It was a childish ignorance,
But now 'tis little joy
To know I'm farther off from Heaven
Than when I was a boy.

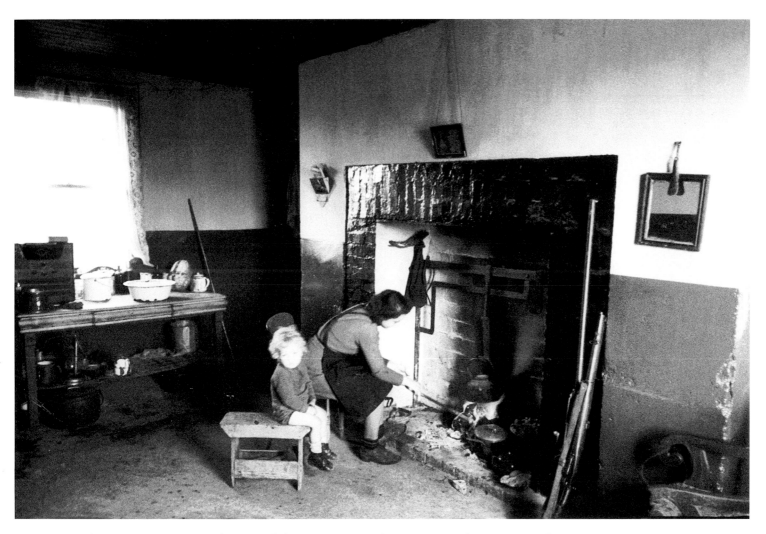

The Annaghdown, County Galway, cottage of Mrs Kavanagh,
showing her daughter Peggy and Peggy's nephew, Gerard Gardiner (1942).

The Snow

Emily Dickinson

It sifts from leaden sieves,
It powders all the wood,
It fills with alabaster wool
The wrinkles of the road.

It makes an even face
Of mountain and of plain,
Unbroken forehead from the east
Unto the east again.

It reaches to the fence,
It wraps it, rail by rail,
Till it is lost in fleeces;
It flings a crystal veil

On stump and stack and stem,
The summer's empty room,
Acres of seams where harvests were,
Recordless, but for them.

It ruffles wrists of posts,
As ankles of a queen,
Then stills its artisans like ghosts,
Denying they have been.

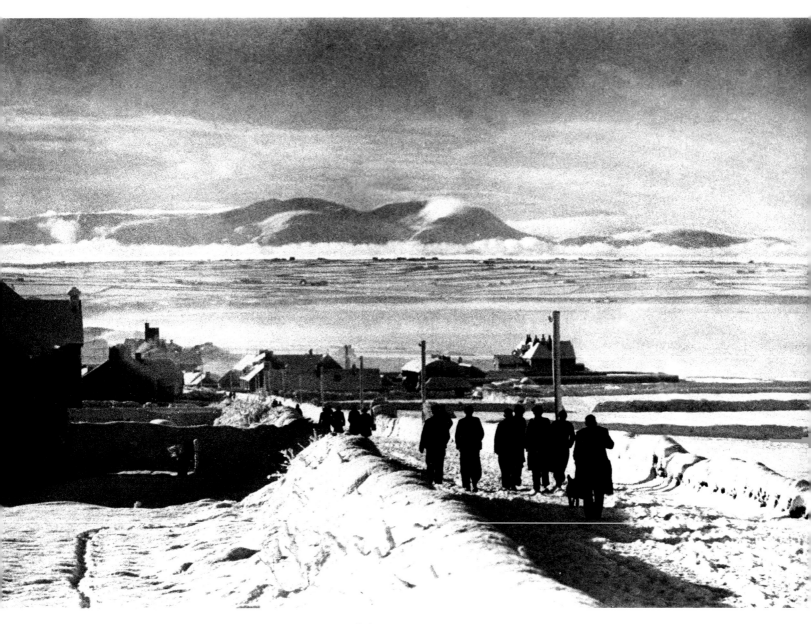

Snow scene, Ballybunion, County Kerry (1945).

A Cradle Song

William Blake

Sweet dreams form a shade,
O'er my lovely infant's head.
Sweet dreams of pleasant streams,
By happy silent moony beams.

Sweet sleep with soft down,
Weave thy brows and infant crown.
Sweet sleep Angel mild,
Hover o'er my happy child.

Sweet smiles in the night,
Hover over my delight.
Sweet smiles mother's smiles,
All the livelong night beguiles.

Sweet moans, dovelike sighs,
Chase not slumber from thy eyes,
Sweet moans, sweeter smiles,
All the dovelike moans beguiles.

Sleep sleep happy child,
All creation slept and smil'd.
Sleep sleep, happy sleep.
While o'er thee thy mother weep

Sweet babe in thy face,
Holy image I can trace.
Sweet babe once like thee.
Thy maker lay and wept for me

Wept for me for thee for all,
When he was an infant small.
Thou his image ever see.
Heavenly face that smiles on thee,

Smiles on thee on me on all,
Who became an infant small,
Infant smiles are his own smiles,
Heaven & earth to peace beguiles.

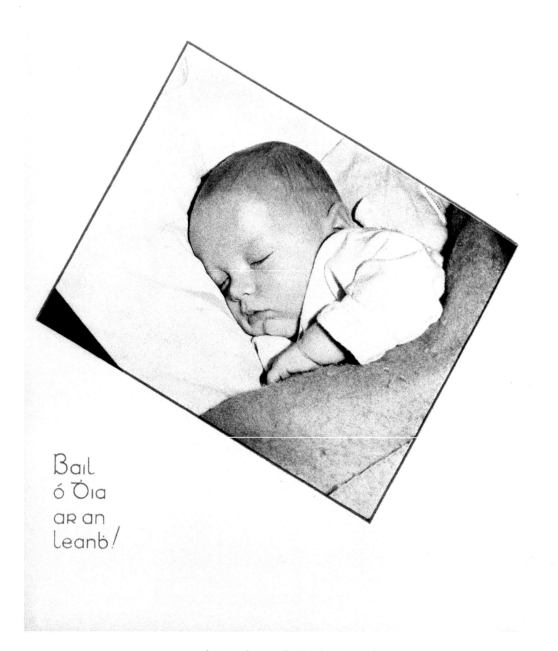

Bail
ó Óia
aR an
leanb!

From the Mother and Child Scheme booklet
published by the Irish Department of Health (1950).

The Crocus

Harriet Beecher Stowe

Beneath the sunny autumn sky,
With gold leaves dropping round,
We sought, my little friend and I,
The consecrated ground,
Where, calm beneath the holy cross,
O'ershadowed by sweet skies,
Sleeps tranquilly that youthful form,
Those blue unclouded eyes.

Around the soft, green swelling mound
We scooped the earth away,
And buried deep the crocus-bulbs
Against a coming day.
'These roots are dry, and brown, and sere;
Why plant them here?' he said,
'To leave them, all the winter long,
So desolate and dead.'

'Dear child, within each sere dead form
There sleeps a living flower,
And angel-like it shall arise
In spring's returning hour.'
Ah, deeper down – cold, dark, and chill –
We buried our heart's flower,
But angel-like shall he arise
In spring's immortal hour.

In blue and yellow from its grave
Springs up the crocus fair,
And God shall raise those bright blue eyes,
Those sunny waves of hair.
Not for a fading summer's morn,
Not for a fleeting hour,
But for an endless age of bliss,
Shall rise our heart's dear flower.

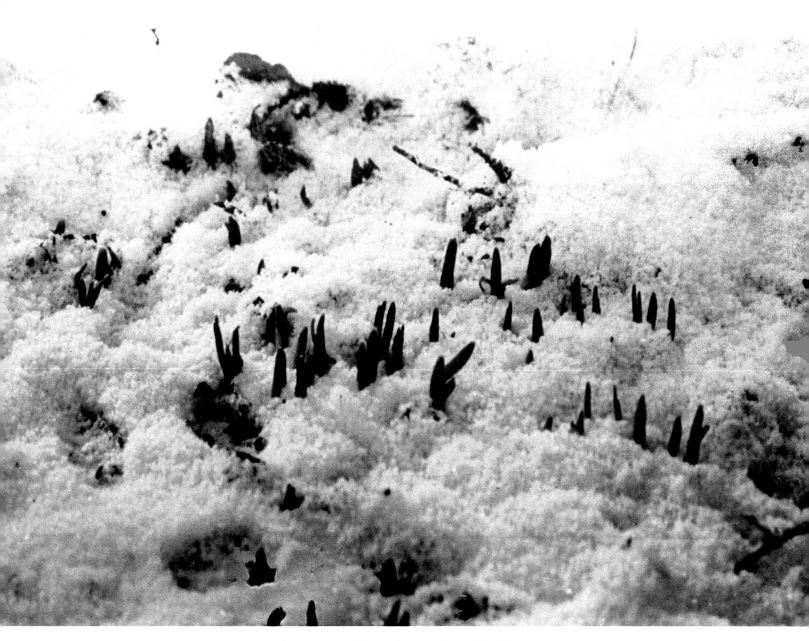

Springtime at Emo, County Laois (1947).

June

Francis Ledwidge

Broom out the floor now, lay the fender by,
And plant this bee-sucked bough of woodbine there,
And let the window down. The butterfly
Floats in upon the sunbeam, and the fair
Tanned face of June, the nomad gipsy, laughs
Above her widespread wares, the while she tells
The farmers' fortunes in the fields, and quaffs
The water from the spider-peopled wells.

The hedges are all drowned in green grass seas,
And bobbing poppies flare like Elmo's light,
While siren-like the pollen-stainèd bees
Drone in the clover depths. And up the height
The cuckoo's voice is hoarse and broke with joy.
And on the lowland crops the crows make raid,
Nor fear the clappers of the farmer's boy,
Who sleeps, like drunken Noah, in the shade.

And loop this red rose in that hazel ring
That snares your little ear, for June is short
And we must joy in it and dance and sing,
And from her bounty draw her rosy worth.
Ay! soon the swallows will be flying south,
The wind wheel north to gather in the snow,
Even the roses spilt on youth's red mouth
Will soon blow down the road all roses go.

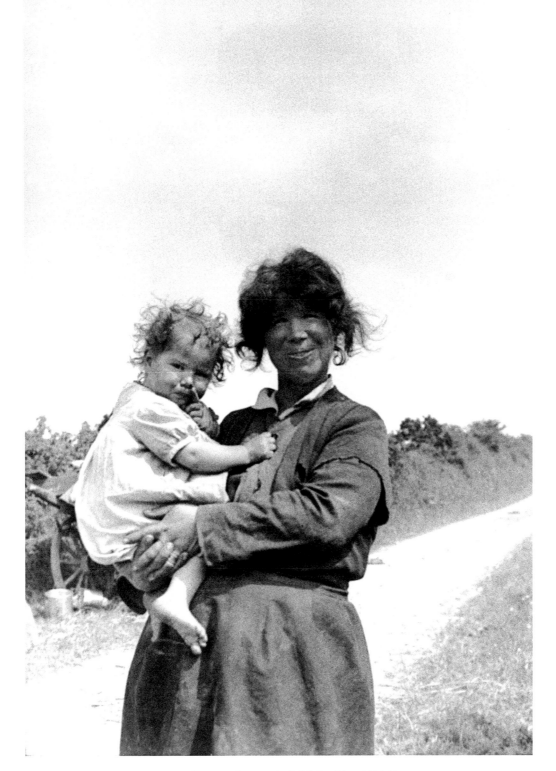

Traveller mother and child, Dublin (1930).

The Wayfarer

Pádraic Pearse

The beauty of the world hath made me sad,
This beauty that will pass;
Sometimes my heart hath shaken with great joy
To see a leaping squirrel in a tree,
Or a red ladybird upon a stalk,
Or little rabbits in a field at evening,
Lit by a slanting sun,
Or some green hill where shadows drifted by
Some quiet hill where mountainy man hath sown
And soon would reap; near to the gate of Heaven;
Or children with bare feet upon the sands
Of some ebbed sea, or playing on the streets
Of little towns in Connacht,
Things young and happy.
And then my heart hath told me:
These will pass,
Will pass and change, will die and be no more,
Things bright and green, things young and happy;
And I have gone upon my way
Sorrowful.

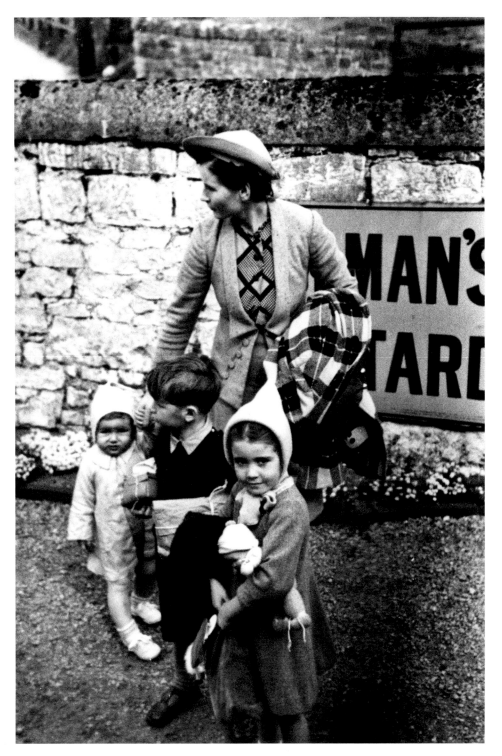

Travelling with Mother, Ballina station, County Mayo (1941).

To the Cuckoo

William Wordsworth

O blithe newcomer! I have heard,
I hear thee and rejoice:
O Cuckoo! shall I call thee bird,
Or but a wandering Voice?

While I am lying on the grass
Thy twofold shout I hear;
From hill to hill it seems to pass,
At once far off and near.

Though babbling only to the vale
Of sunshine and of flowers,
Thou bringest unto me a tale
Of visionary hours.

Thrice welcome, darling of the Spring!
Even yet thou art to me
No bird, but an invisible thing,
A voice, a mystery;

The same whom in my schoolboy days
I listened to; that Cry
Which made me look a thousand ways
In bush, and tree, and sky.

To seek thee did I often rove
Through woods and on the green;
And thou wert still a hope, a love;
Still longed for, never seen!

And I can listen to thee yet;
Can lie upon the plain
And listen, till I do beget
That golden time again.

O blessed Bird! the earth we pace
Again appears to be
An unsubstantial, faery place,
That is fit home for Thee!

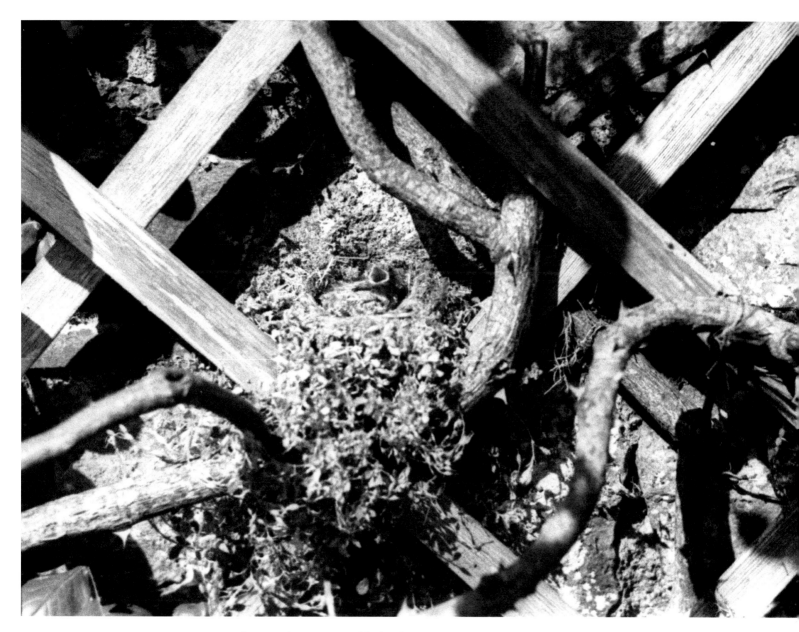

Cuckoo in the nest, Leighlinbridge, County Carlow (1940).

The Daffodils

William Wordsworth

I wndered lonely as a cloud
That floats on high o'er vales and hills,
When all at once I saw a crowd,
A host, of golden daffodils;
Beside the lake, beneath the trees,
Fluttering and dancing in the breeze.

Continuous as the stars that shine
And twinkle on the Milky Way,
They stretch'd in never-ending line
Along the margin of a bay:
Ten thousand saw I at a glance,
Tossing their heads in sprightly dance.

The waves beside them danced; but they
Out-did the sparkling waves in glee:
A poet could not but be gay,
In such a jocund company:
I gazed – and gazed – but little thought
What wealth the show to me had brought:

For oft, when on my couch I lie
In vacant or in pensive mood,
They flash upon that inward eye
Which is the bliss of solitude;
And then my heart with pleasure fills,
And dances with the daffodils.

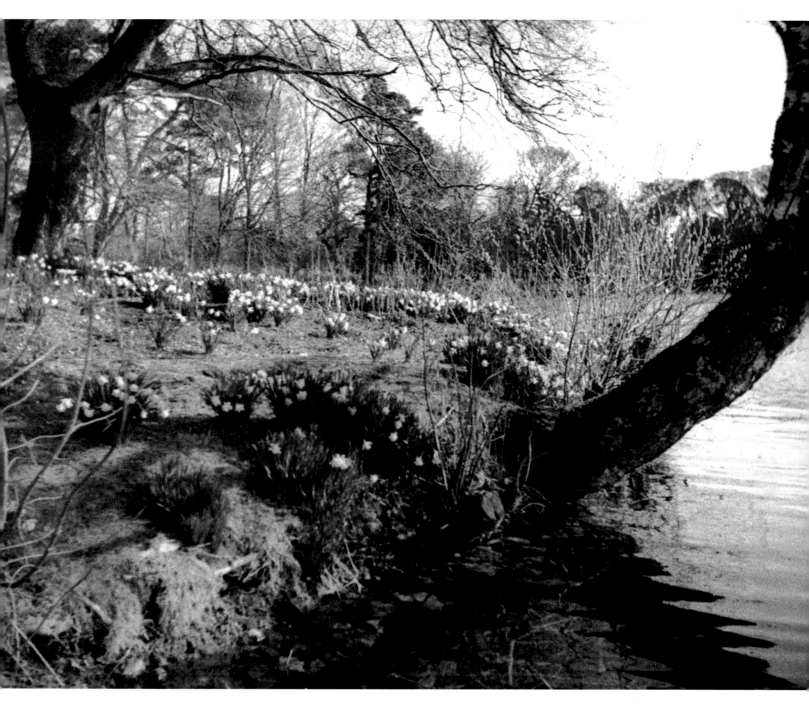

'Beside the lake, beneath the trees', Emo, County Laois (1937).

My Land

Thomas Davis

She is a rich and rare land;
Oh! she's a fresh and fair land;
She is a dear and rare land –
This native land of mine.

No men than hers are braver –
Her women's hearts never waver;
I'd freely die to save her,
And think my lot divine.

She's not a dull or cold land;
No! She's a warm and bold land;
Oh! she's a true and old land –
This native land of mine.

Could beauty ever guard her,
And virtue still reward her,
No foe would cross her border –
No friend within it pine!

Oh! she's a fresh and fair land;
Oh! she's a true and rare land;
Yes! She's a rare and fair land –
This native land of mine.

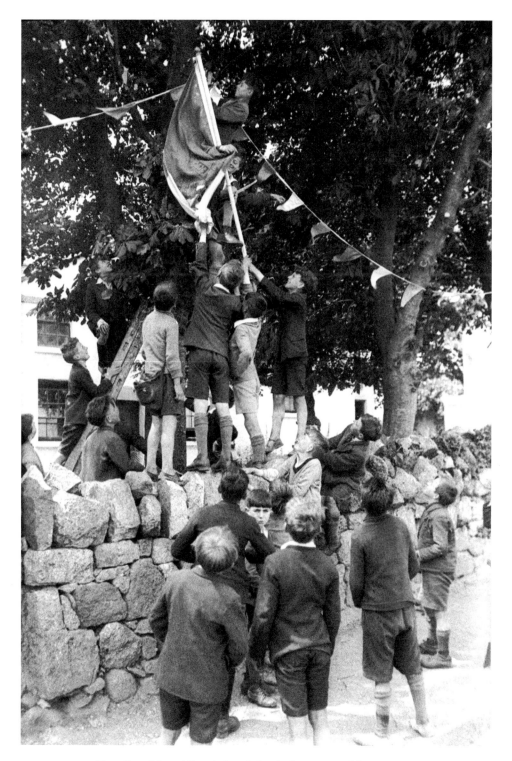

'Put Out More Flags', Sandyford, County Dublin (1932).

The Year

Coventry Patmore

The crocus, while the days are dark,
Unfolds its saffron sheen
At April's touch, the crudest bark,
Discovers gems of green.

Then sleep the seasons, full of might;
While slowly swells the pod
And rounds the beach, and in the night,
The mushroom bursts the sod.

The Winter falls; the frozen rut,
Is bound with silver bars,
The snow-drift heaps against the hut,
And night is pierced with stars.

'Winter Solitude', Killarney, County Kerry (1909).

The Child is Father to the Man

Gerard Manley Hopkins

'The child is father to the man.'
How can he be? The words are wild.
Suck any sense from that who can:
'The child is father to the man.'
No; what the poet did write ran,
'The man is father to the child.'
'The child is father to the man!'
How can he be? The words are wild.

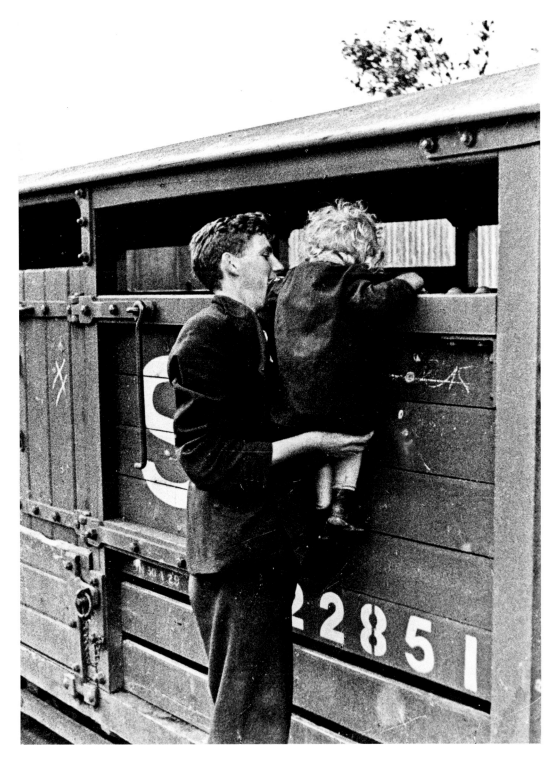

'Looking in', Liffey Junction, Dublin (1942).

Ich am of Irlaunde

Anon
(14th Century)

Ich am of Irlaunde,
Ant of the holy londe
Of Irlande.
Gode sire, pray ich the,
For of saynte charité,
Com ant daunce wyth me
In Irlaunde.

[I am of Ireland,
And of the holy land
Of Ireland.
Good Sir, I pray thee
For the sake of Charity
Come and dance with me
In Ireland.]

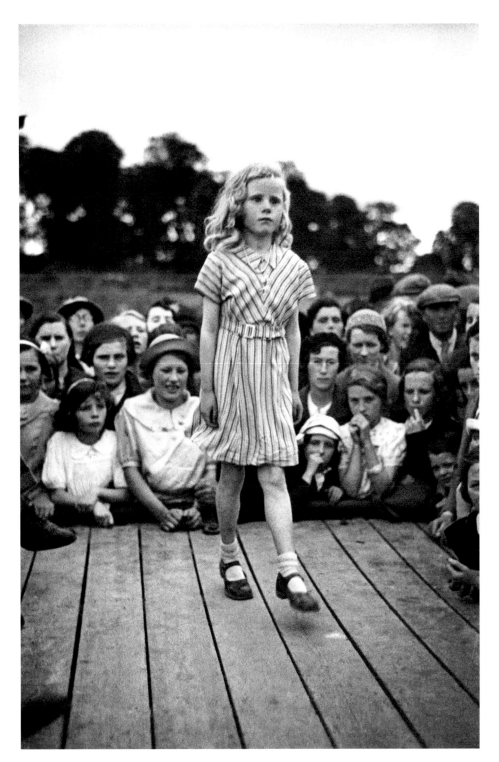

Irish dancing, Emo, County Laois (1938).

Lucy

William Wordsworth

She dwelt among the untrodden ways
Beside the springs of Dove;
A maid whom there were none to praise,
And very few to love.

A violet by a mossy stone
Half-hidden from the eye!
Fair as a star, when only one
Is shining in the sky.

She lived unknown, and few could know
When Lucy ceased to be;
But she is in her grave, and, oh,
The difference to me!

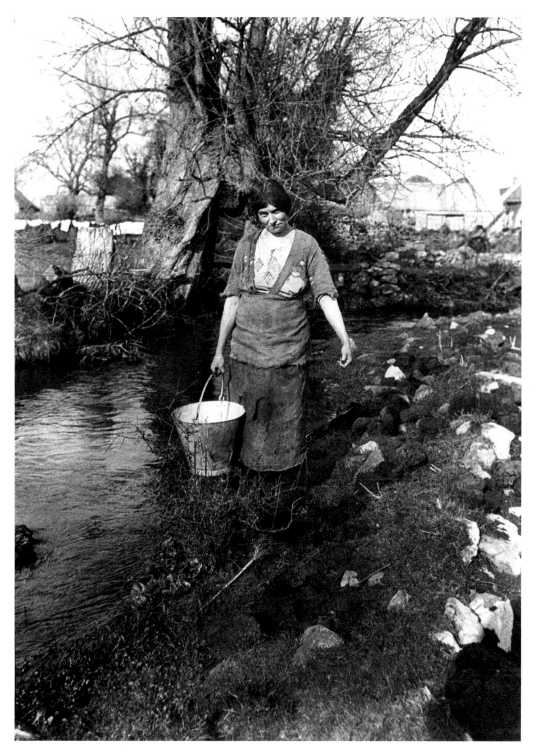

The miller's daughter, Miss Scott, at Oughter, County Offaly (1929).

Spring

Gerard Manley Hopkins

Nothing is so beautiful as spring –
When weeds, in wheels, shoot long and lovely and lush;
Thrush's eggs look little low heavens, and thrush
Through the echoing timber does so rinse and wring
The ear, it strikes like lightnings to hear him sing;
The glassy peartree leaves and blooms, they brush
The descending blue; that blue is all in a rush
With richness; the racing lambs too have fair their fling.

What is all this juice and all this joy?
A strain of the earth's sweet being in the beginning
In Eden garden. – Have, get, before it cloy,
Before it cloud, Christ, lord, and sour with sinning,
Innocent mind and Mayday in girl and boy,
Most, O maid's child, thy choice and worthy the winning.

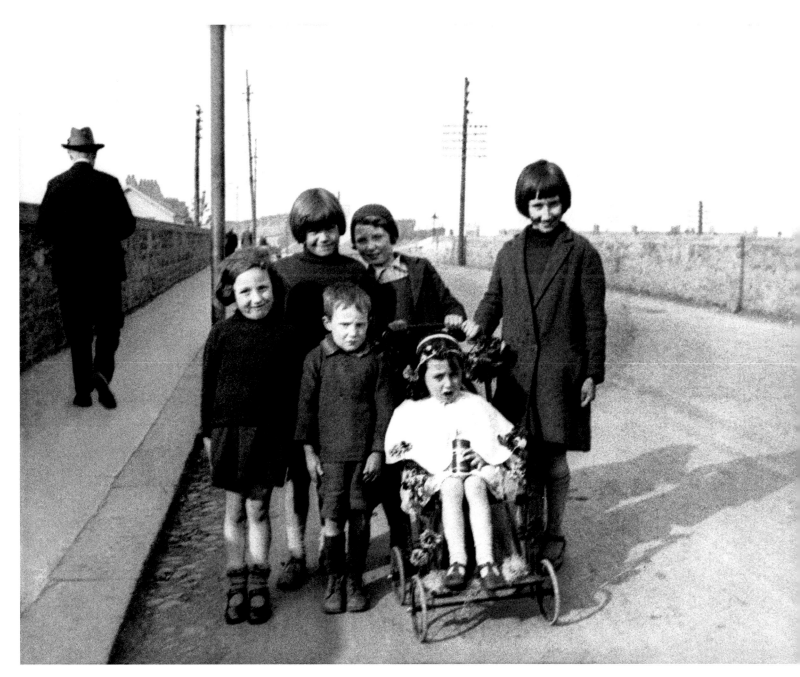

'Queen of the May', Portadown, County Armagh (1933).

Home, Sweet Home

Thomas R. Lounsbury

'Mid pleasures and palaces though we may roam,
Be it ever so humble, there's no place like home;
A charm from the sky seems to hallow us there,
Which, seek through the world, is ne'er met with elsewhere.
Home! Home! sweet, sweet Home!
There's no place like Home! there's no place like Home!

An exile from Home, splendour dazzles in vain;
O, give me my lowly thatched cottage again!
The birds singing gaily, that came at my call, –
Give me them, – and the peace of mind, dearer than all!
Home! Home! sweet, sweet Home!
There's no place like Home! there's no place like Home!

How sweet 'tis to sit 'neath a fond father's smile,
And the cares of a mother to soothe and beguile!
Let others delight 'mid new pleasures to roam,
But give me, oh, give me, the pleasures of Home!
Home! Home! sweet, sweet Home!
There's no place like Home! there's no place like Home!

To thee I'll return, overburdened with care;
The heart's dearest solace will smile on me there;
No more from that cottage again will I roam;
Be it ever so humble, there's no place like Home.
Home! Home! sweet, sweet Home!
There's no place like Home!

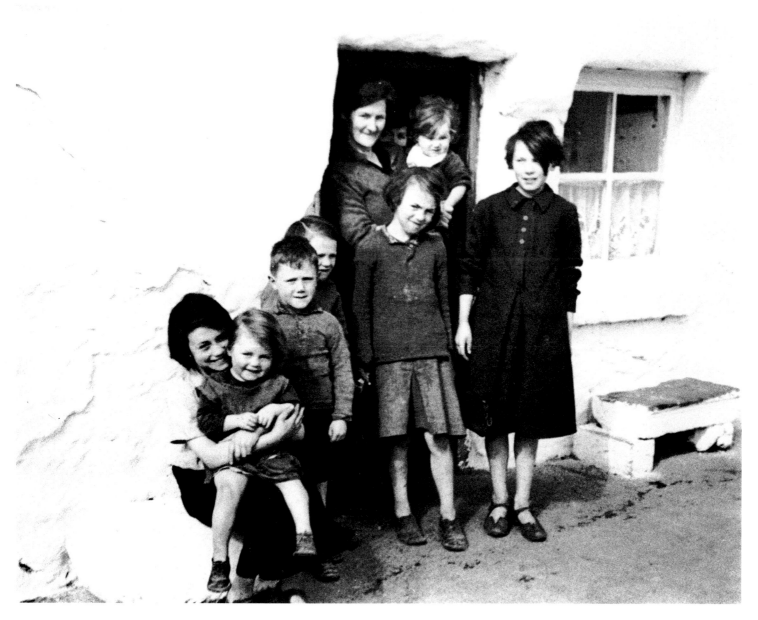

A happy family at Ballinasloe, County Galway (1938).

The Ocean

Nathaniel Hawthorne

The Ocean has its silent caves,
Deep, quiet and alone;
Though there be fury on the waves,
Beneath them there is none.
The awful spirits of the deep
Hold their communion there;
And there are those for whom we weep,
The young, the bright, the fair.

Calmly the wearied seamen rest
Beneath their own blue sea.
The ocean solitudes are blest,
For there is purity.
The earth has guilt, the earth has care,
Unquiet are its graves;
But peaceful sleep is ever there,
Beneath the dark blue waves.

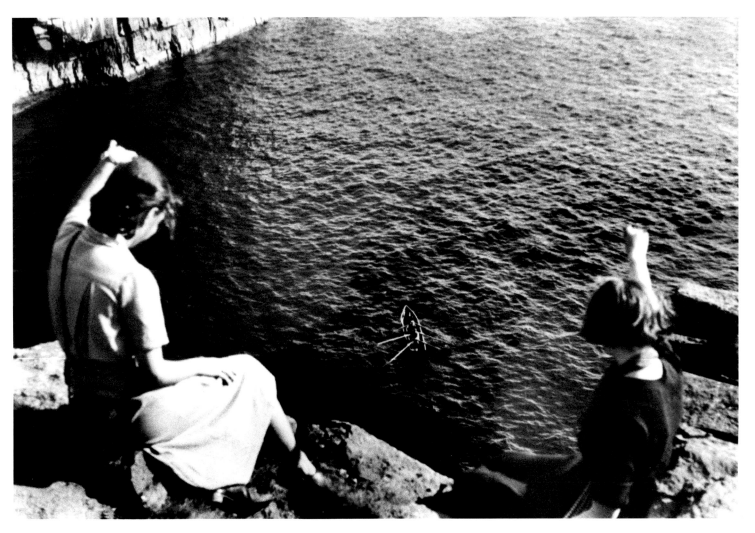

On the cliff-tops of the Aran Islands (1938).

The Village Schoolmaster

Oliver Goldsmith

(An extract from 'The Deserted Village')

Beside yon straggling fence that skirts the way,
With blossomed furze unprofitably gay,
There, in his noisy mansion, skilled to rule,
The village master taught his little school;
A man severe he was, and stern to view;
I knew him well, and every truant knew;
Well had the boding tremblers learned to trace
The day's disasters in his morning face;
Full well they laughed, with counterfeited glee,
At all his jokes, for many a joke had he;
Full well the busy whisper, circling round,
Conveyed the dismal tidings when he frowned;
Yet he was kind; or if severe in aught,
The love he bore to learning was in fault.
The village all declared how much he knew;
'Twas certain he could write, and cipher too;
Lands he could measure, terms and tides presage,
And even the story ran that he could gauge.
In arguing too, the parson owned his skill,
For e'en though vanquished, he could argue still;
While words of learned length and thundering sound
Amazed the gazing rustics ranged around,
And still they gazed, and still the wonder grew
That one small head could carry all he knew.

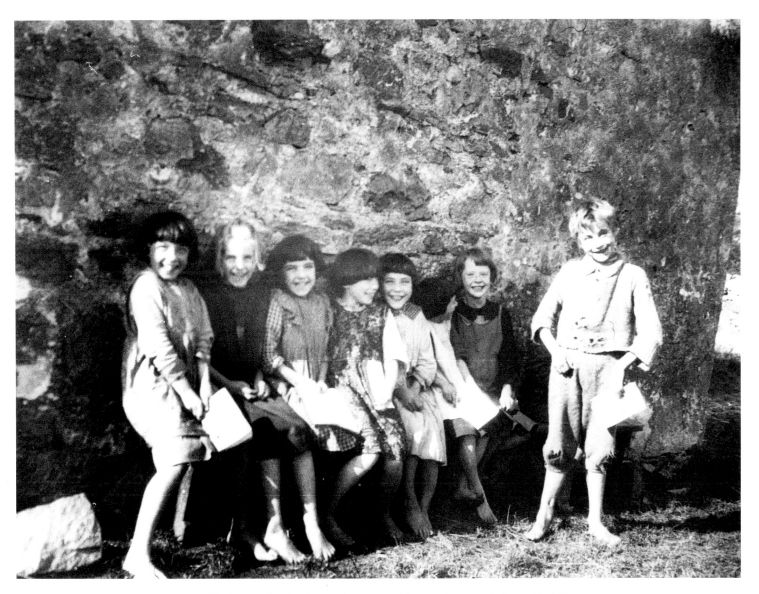

'*Little Gaels*': *Irish speakers near Maam, County Galway (1925).*

Home Thoughts, From Abroad

Robert Browning

Oh, to be in England
Now that April's there,
And whoever wakes in England
Sees, some morning, unaware,
That the lowest boughs and the brushwood sheaf
Round the elm-tree bole are in tiny leaf,
While the chaffinch sings on the orchard bough
In England – now!

And after April, when May follows,
And the whitethroat builds, and all the swallows!
Hark, where my blossom'd pear-tree in the hedge
Leans to the field and scatters on the clover
Blossoms and dewdrops – at the bent spray's edge –
That's the wise thrush; he sings each song twice over,
Lest you should think he never could recapture
The first fine careless rapture!
And though the fields look rough with hoary dew,
All will be gay when noontide wakes anew
The buttercups, the little children's dower
– Far brighter than this gaudy melon-flower!

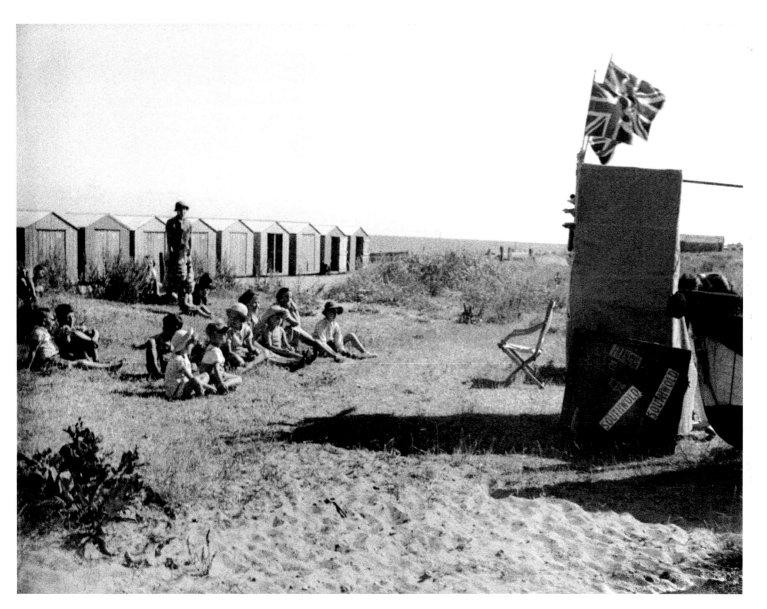

Punch and Judy show on the strand at Walberswick, Suffolk (1933).

Pied Beauty

Gerard Manley Hopkins

Glory be to God for dappled things –
For skies of couple-colour as a brindled cow;
For rose-moles all in stipple upon trout that swim;
Fresh-firecoal chestnut-falls; finches' wings;
Landscape plotted and pieced – fold, fallow, and plough;
And áll trádes, their gear and tackle and trim.

All things counter, original, spare, strange;
Whatever is fickle, freckled (who knows how?)
With swift, slow; sweet, sour; adazzle, dim;
He fathers-forth whose beauty is past change:
Praise him.

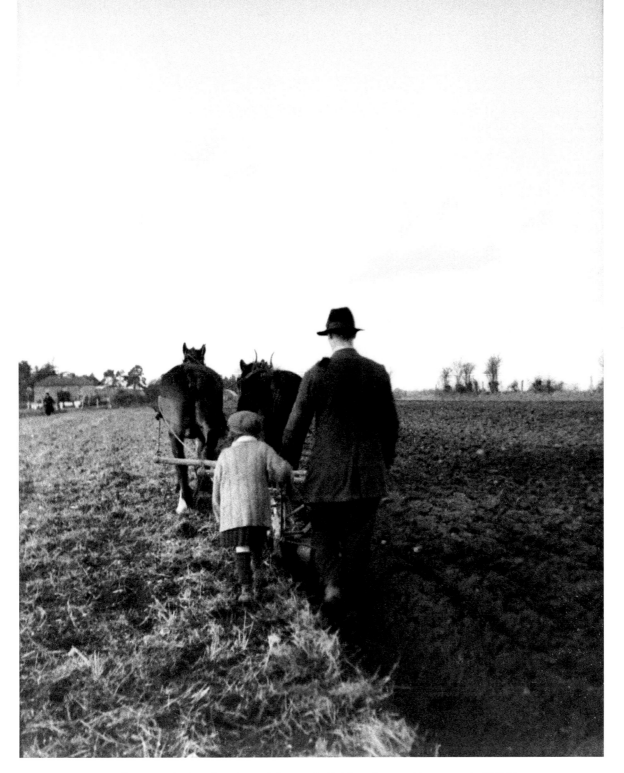

Helping with the ploughing, Maguire's Bridge, County Fermanagh (1930).

Westminster Bridge

William Wordsworth

Earth has not anything to show more fair:
Dull would he be of soul who could pass by
A sight so touching in its majesty:
This City now doth, like a garment, wear
The beauty of the morning; silent, bare,
Ships, towers, domes, theatres and temples lie
Open unto the fields, and to the sky;
All bright and glittering in the smokeless air.
Never did sun more beautifully steep
In his first splendour, valley, rock, or hill;
Ne'er saw I, never felt, a calm so deep!
The river glideth at his own sweet will:
Dear God! the very houses seem asleep;
And all that mighty heart is lying still!

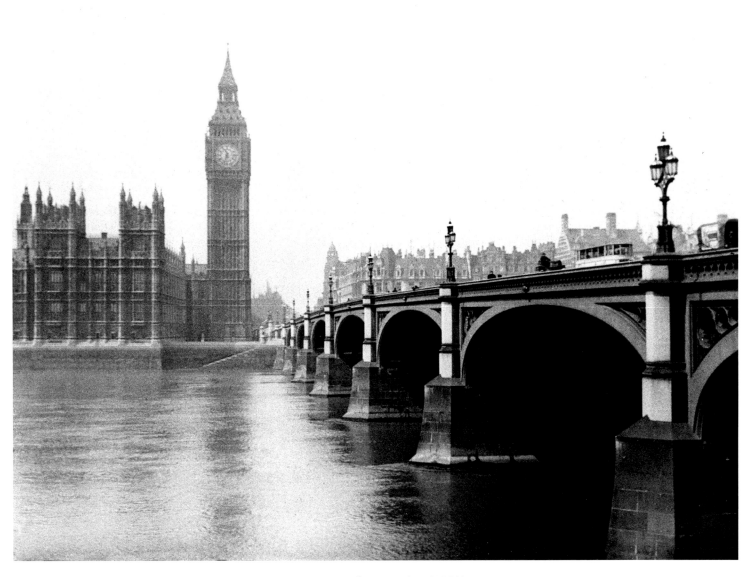

Westminster Bridge, London (1909).

Angels

Emily Dickinson

Angels, in the early morning
May be seen the Dews among,
Stooping, plucking, smiling, flying;
Do the Buds to them belong?

Angels, when the sun is hottest
May be seen the sands among,
Stooping, plucking, sighing, flying;
Parched the flowers they bear along.

'School of Art', Basin Lane, Dublin (1939).

After Sunset

William Allingham

The vast and solemn company of clouds
Around the Sun's death, lit, incarnadined,
Cool into ashy wan; as Night enshrouds
The level pasture, creeping up behind
Through voiceless vales, o'er lawn and purpled hill
And hazèd mead, her mystery to fulfil.
Cows low from far-off farms; the loitering wind
Sighs in the hedge, you hear it if you will, –
Tho' all the wood, alive atop with wings
Lifting and sinking through the leafy nooks,
Seethes with the clamour of a thousand rooks.
Now every sound at length is hush'd away.
These few are sacred moments. One more Day
Drops in the shadowy gulf of bygone things.

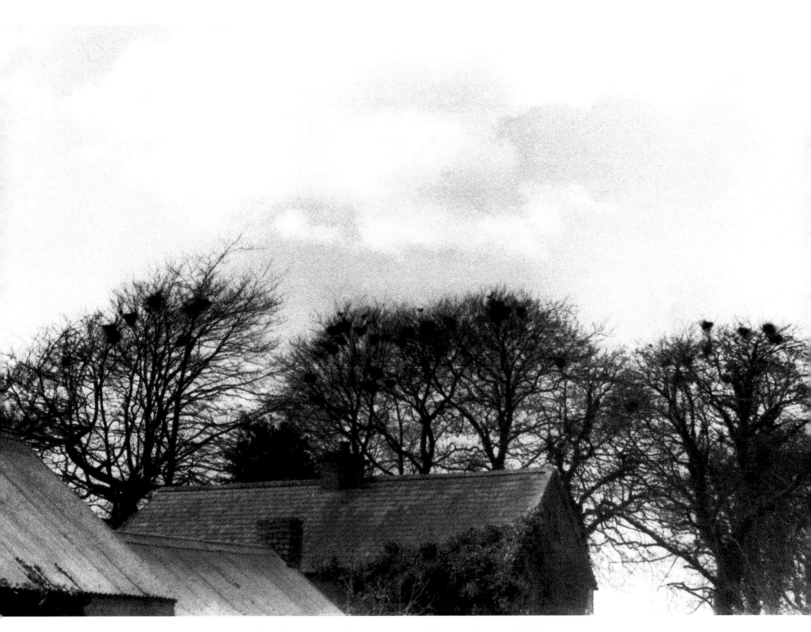

Clouds over Rookery, New Inn, County Laois (1943).

Ozymandias

Percy Bysshe Shelley

I met a traveller from an antique land
Who said: Two vast and trunkless legs of stone
Stand in the desert. Near them on the sand,
Half sunk, a shatter'd visage lies, whose frown
And wrinkled lip and sneer of cold command
Tell that its sculptor well those passions read
Which yet survive, stamp'd on these lifeless things,
The hand that mock'd them and the heart that fed.
And on the pedestal these words appear:
'My name is Ozymandias, king of kings:
Look on my works, ye mighty, and despair!'
Nothing beside remains: round the decay
Of that colossal wreck, boundless and bare,
The lone and level sands stretch far away.

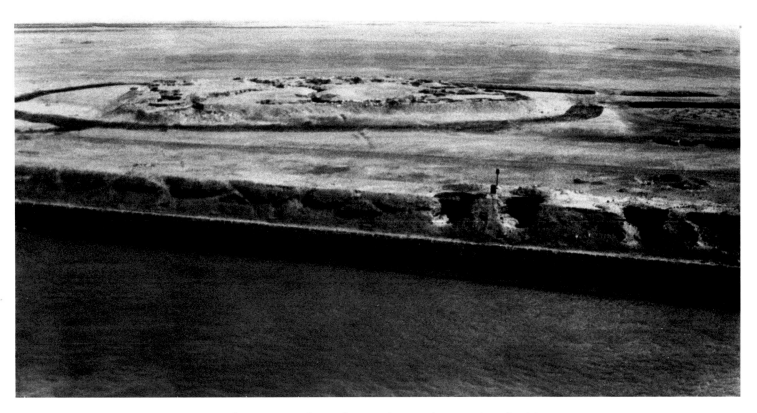

The Egyptian desert from a ship on the Suez Canal (1925).

Sonnet 18

William Shakespeare

Shall I compare thee to a summer's day?
Thou art more lovely and more temperate:
Rough winds do shake the darling buds of May,
And summer's lease hath all too short a date:
Sometime too hot the eye of heaven shines,
And often is his gold complexion dimm'd,
And every fair from fair sometime declines,
By chance, or nature's changing course untrimm'd:
But thy eternal summer shall not fade,
Nor lose possession of that fair thou ow'st,
Nor shall death brag thou wander'st in his shade,
When in eternal lines to time thou grow'st,
So long as men can breathe, or eyes can see,
So long lives this, and this gives life to thee.

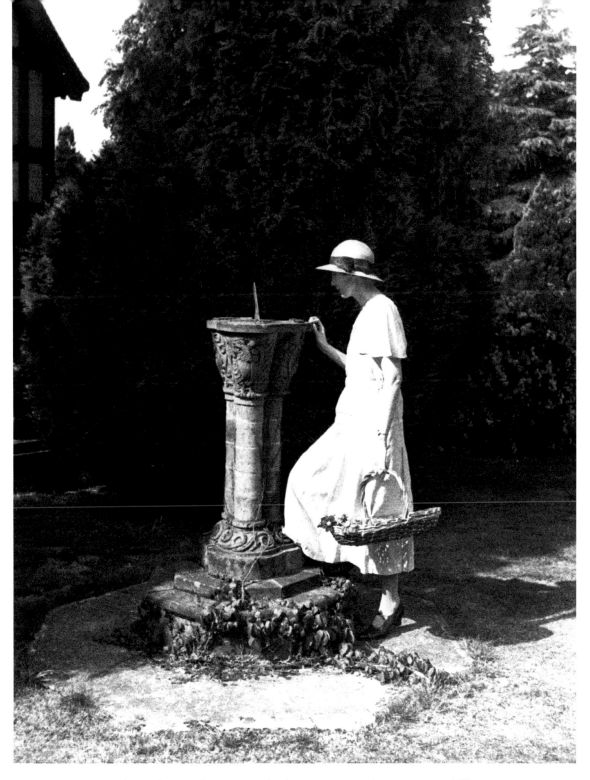

Mrs Taylor in her garden at 'Heatherbrae', near Castle Rising, Norfolk (1935).

The Good Shepherd with the Kid

Matthew Arnold

He saves the sheep, the goats he doth not save!
So rang Tertullian's sentence, on the side
Of that unpitying Phrygian sect which cried:
'Him can no fount of fresh forgiveness lave,
Who sins, once wash'd by the baptismal wave!'
So spake the fierce Tertullian. But she sigh'd,
The infant Church; of love she felt the tide
Stream on her from her Lord's yet recent grave.
And then she smiled, and in the Catacombs,
With eye suffused but heart inspired true,
On those walls subterranean, where she hid
Her head in ignominy, death, and tombs,
She her Good Shepherd's hasty image drew;
And on his shoulders, not a lamb, a kid.

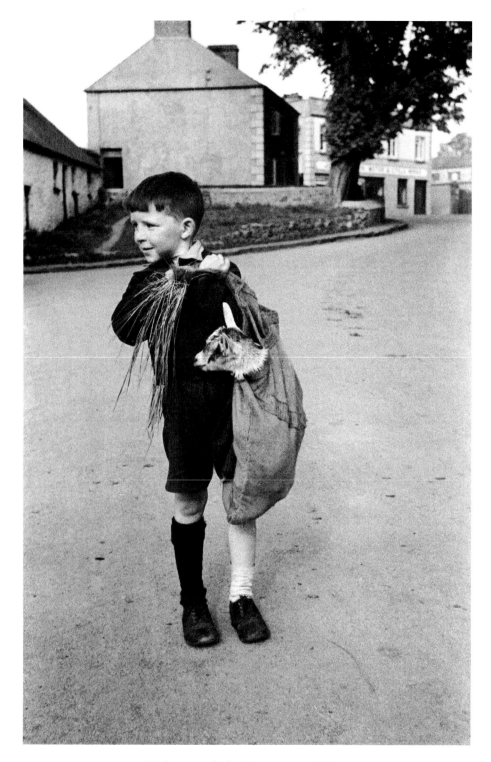

'Kid carries kid', Cavan town (1938).

To Autumn

John Keats

Season of mists and mellow fruitfulness!
Close bosom-friend of the maturing sun;
Conspiring with him how to load and bless
With fruit the vines that round the thatch-eves run;
To bend with apples the moss'd cottage-trees,
And fill all fruit with ripeness to the core;
To swell the gourd, and plump the hazel shells
With a sweet kernel; to set budding more,
And still more, later flowers for the bees,
Until they think warm days will never cease,
For Summer has o'er-brimm'd their clammy cells.

Who hath not seen thee oft amid thy store?
Sometimes whoever seeks abroad may find
Thee sitting careless on a granary floor,
Thy hair soft-lifted by the winnowing wind;
Or on a half-reap'd furrow sound asleep,
Drowsed with the fumes of poppies, while thy hook
Spares the next swath and all its twined flowers;
And sometime like a gleaner thou dost keep
Steady thy laden head across a brook;
Or by a cider-press, with patient look,
Thou watchest the last oozings, hours by hours.

Where are the songs of Spring? Ay, where are they?
Think not of them, thou hast thy music too,
While barred clouds bloom the soft-dying day,
And touch the stubble-plains with rosy hue;
Then in a wailful choir, the small gnats mourn
Among the river sallows, borne aloft
Or sinking as the light wind lives or dies;
And full-grown lambs loud bleat from hilly bourn;
Hedge-crickets sing; and now with treble soft
The redbreast whistles from a garden-croft,
And gathering swallows twitter in the skies.

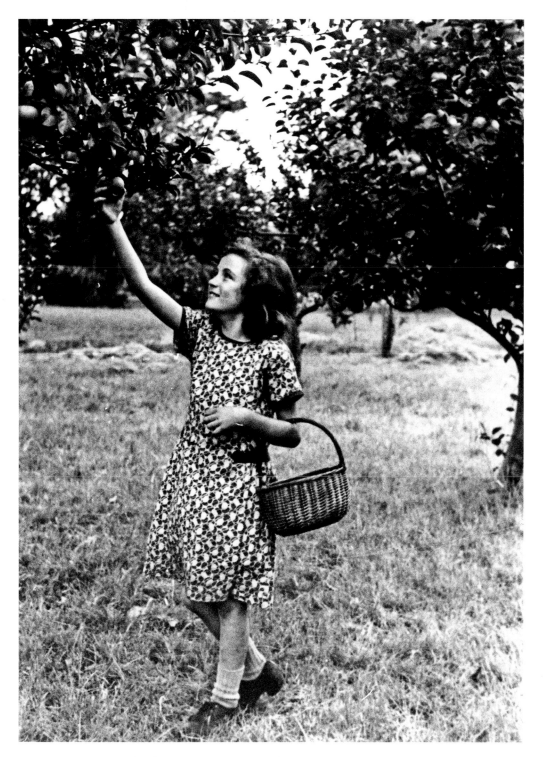

Apple harvest at the Good Shepherd Convent, Limerick (1939).

London Snow

Robert Bridges

When men were all asleep the snow came flying,
In large white flakes falling on the city brown,
Stealthily and perpetually settling and loosely lying,
Hushing tvhe latest traffic of the drowsy town;
Deadening, muffling, stifling its murmurs failing;
Lazily and incessantly floating down and down:
Silently sifting and veiling road, roof and railing;
Hiding difference, making unevenness even,
Into angles and crevices softly drifting and sailing.
All night it fell, and when full inches seven
It lay in the depth of its uncompacted lightness,
The clouds blew off from a high and frosty heaven;
And all woke earlier for the unaccustomed brightness
Of the winter dawning, the strange unheavenly glare:
The eye marvelled – marvelled at the
 dazzling whiteness;
The ear hearkened to the stillness of the solemn air;
No sound of wheel rumbling nor of foot falling,
And the busy morning cries came thin and spare.

Then boys I heard, as they went to school, calling,
They gathered up the crystal manna to freeze
Their tongues with tasting, their hands
 with snowballing;
Or rioted in a drift, plunging up to the knees;
Or peering up from under the white-mossed wonder!'
'O look at the trees!' they cried, 'O look at the trees!'
With lessened load a few carts creak and blunder,
Following along the white deserted way,
A country company long dispersed asunder:
When now already the sun, in pale display
Standing by Paul's high dome, spread forth below
His sparkling beams, and awoke the stir of the day.
For now doors open, and war is waged with the snow;
And trains of sombre men, past tale of number,
Tread long brown paths, as toward their toil they go:
But even for them awhile no cares encumber
Their minds diverted; the daily word is unspoken,
The daily thoughts of labour and sorrow slumber
At the sight of the beauty that greets them, for the
 charm they have broken.

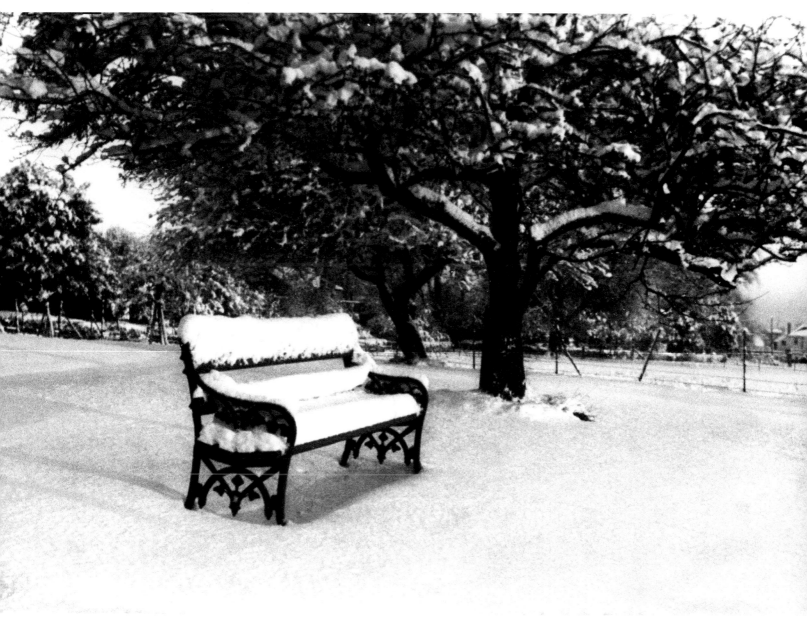

Snow on a city seat, Dublin (1941).

Skating

William Wordsworth

And in the frosty season, when the sun
Was set, and visible for many a mile
The cottage windows blazed through twilight gloom,
I heeded not their summons: happy time
It was indeed for all of us – for me
It was a time of rapture! Clear and loud
The village clock tolled six, – I wheeled about,
Proud and exulting like an untired horse
That cares not for his home. All shod with steel,
We hissed along the polished ice in games
Confederate, imitative of the chase
And woodland pleasures, – the resounding horn,
The pack loud chiming, and the hunted hare.
So through the darkness and the cold we flew,
And not a voice was idle; with the din
Smitten, the precipices rang aloud;
The leafless trees and every icy crag
Tinkled like iron; while far distant hills
Into the tumult sent an alien sound
Of melancholy not unnoticed, while the stars
Eastward were sparkling clear, and in the west
The orange sky of evening died away.
Not seldom from the uproar I retired
Into a silent bay, or sportively
Glanced sideway, leaving the tumultuous throng,
To cut across the reflex of a star
That fled, and, flying still before me, gleamed
Upon the glassy plain; and oftentimes,
When we had given our bodies to the wind,
And all the shadowy banks on either side
Came sweeping through the darkness, spinning still
The rapid line of motion, then at once
Have I, reclining back upon my heels,
Stopped short; yet still the solitary cliffs
Wheeled by me – even as if the earth had rolled
With visible motion her diurnal round!
Behind me did they stretch in solemn train,
Feebler and feebler, and I stood and watched
Till all was tranquil as a dreamless sleep.

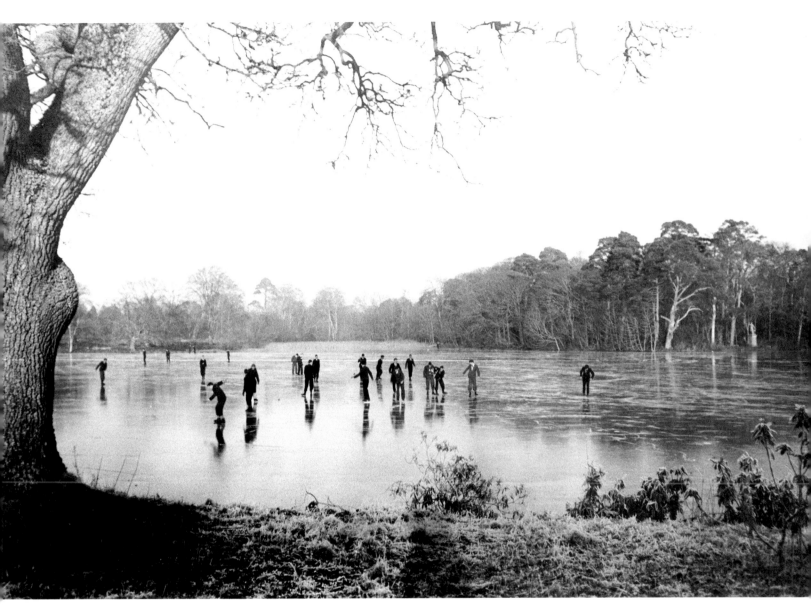

Skating on Emo Lake, County Laois (1935).

Sonnet 57

Gerard Manley Hopkins

As kingfishers catch fire, dragonflies draw flame;
As tumbled over rim in roundy wells
Stones ring; like each tucked string tells, each hung bell's
Bow swung finds tongue to fling out broad its name;
Each mortal thing does one thing and the same:
Deals out that being indoors each one dwells;
Selves – goes itself, myself it speaks and spells,
Crying What I do is me: for that I came.

Í say more: the just man justices;
Keeps gráce: thát keeps all his goings graces;
Acts in God's eye what in God's eye he is –
Christ. For Christ plays in ten thousand places,
Lovely in limbs, and lovely in eyes not his
To the Father through the features of men's faces.

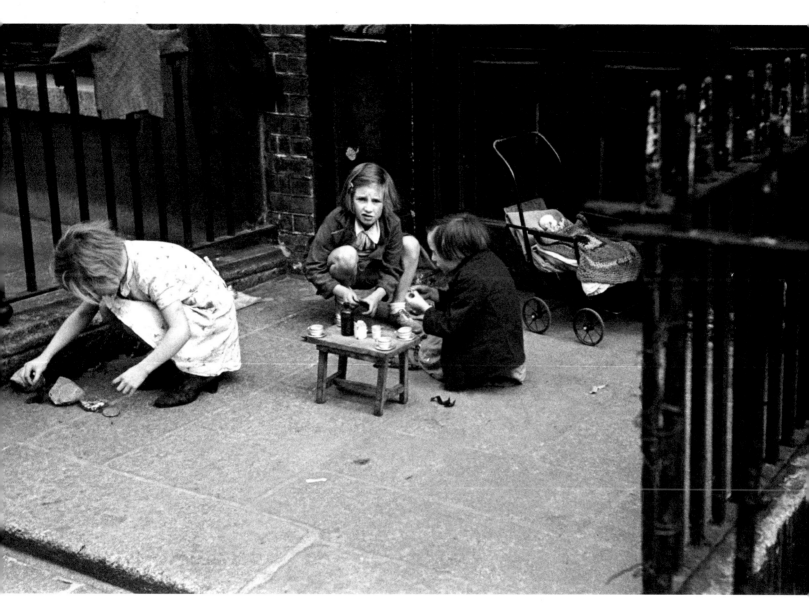

Children's tea party, Temple Street, Dublin (1940).

The Celestial Surgeon

Robert Louis Stevenson

If I have faltered more or less
In my great task of happiness;
If I have moved among my race
And shown no glorious morning face;
If beams from happy human eyes
Have moved me not; if morning skies,
Books, and my food, and summer rain
Knocked on my sullen heart in vain: –
Lord, thy most pointed pleasure take
And stab my spirit broad awake;
Or, Lord, if too obdurate I,
Choose thou, before that spirit die,
A piercing pain, a killing sin,
And to my dead heart run them in!

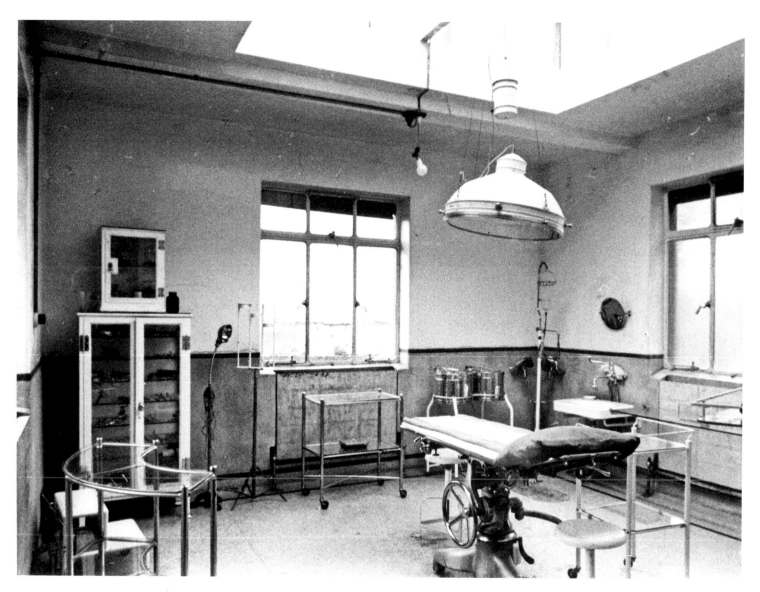

Operating theatre, Limerick City Hospital (1944).

Recessional

Rudyard Kipling

God of our fathers, known of old –
Lord of our far-flung battle-line –
Beneath whose awful Hand we hold
Dominion over palm and pine –
Lord God of Hosts, be with us yet,
Lest we forget, lest we forget!

The tumult and the shouting dies –
The captains and the kings depart –
Still stands Thine ancient sacrifice,
An humble and a contrite heart.
Lord God of Hosts, be with us yet,
Lest we forget, lest we forget!

Far-call'd our navies melt away –
On dune and headland sinks the fire –
Lo, all our pomp of yesterday
Is one with Nineveh and Tyre!
Judge of the Nations, spare us yet,
Lest we forget, lest we forget!

If, drunk with sight of power, we loose
Wild tongues that have not Thee in awe –
Such boasting as the Gentiles use
Or lesser breeds without the Law –
Lord God of Hosts, be with us yet,
Lest we forget, lest we forget!

For heathen heart that puts her trust
In reeking tube and iron shard –
All valiant dust that builds on dust,
And guarding calls not Thee to guard –
For frantic boast and foolish word,
Thy Mercy on Thy People, Lord!

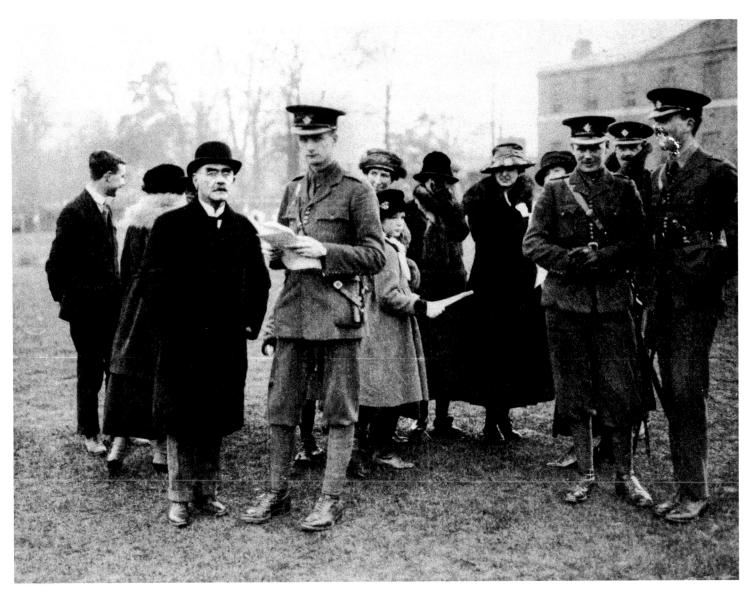

Rudyard Kipling visiting Warley Barracks, Essex (1929).

Reveille

A. E. Housman

Wake: the silver dusk returning
Up the beach of darkness brims,
And the ship of sunrise burning
Strands upon the eastern rims.

Wake: the vaulted shadow shatters,
Trampled to the floor it spanned,
And the tent of night in tatters
Straws the sky-pavilioned land.

Up, lad, up, 'Tis late for lying:
Hear the drums of morning play;
Hark, the empty highways crying
'Who'll beyond the hills away?'

Towns and countries woo together,
Forelands beacon, belfries call;
Never lad that trod on leather
Lived to feast his heart with all.

Up, lad: thews that lie and cumber
Sunlit pallets never thrive;
Morns abed and daylight slumber
Were not meant for man alive.

Clay lies still, but blood's a rover;
Breath's a ware that will not keep.
Up, lad: when the journey's over
There'll be time enough to sleep.

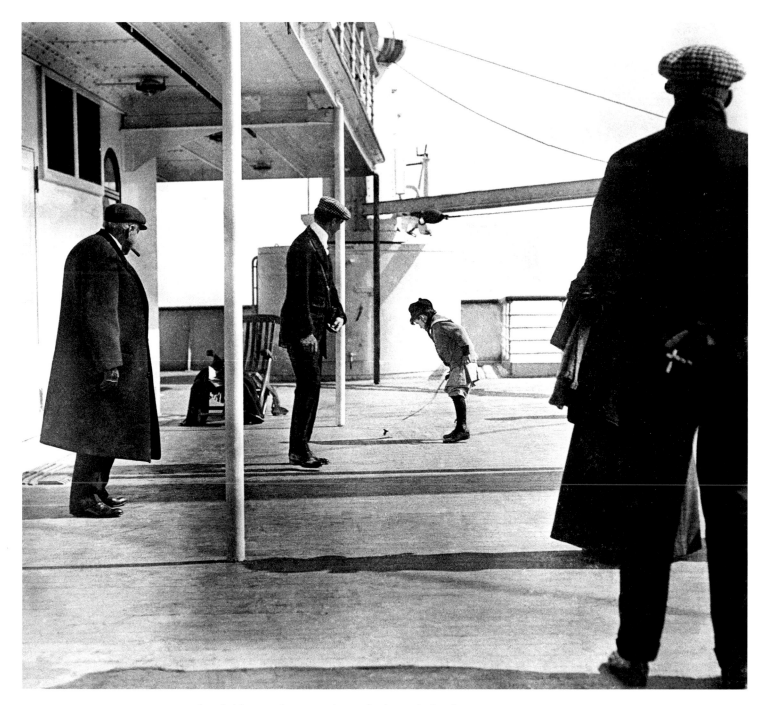

'The children's playground' on the boat deck of R.M.S. Titanic (1912).

Lead, Kindly Light

John Henry Newman

Lead, kindly Light, amid th'encircling gloom, lead Thou me on!
The night is dark, and I am far from home; lead Thou me on!
Keep Thou my feet; I do not ask to see
The distant scene; one step enough for me.

I was not ever thus, nor prayed that Thou shouldst lead me on;
I loved to choose and see my path; but now lead Thou me on!
I loved the garish day, and, spite of fears,
Pride ruled my will. Remember not past years!

So long Thy power hath blest me, sure it still will lead me on.
O'er moor and fen, o'er crag and torrent, till the night is gone,
And with the morn those angel faces smile, which I
Have loved long since, and lost awhile!

Meantime, along the narrow rugged path, Thyself hast trod,
Lead, Saviour, lead me home in childlike faith, home to my God.
To rest forever after earthly strife
In the calm light of everlasting life.

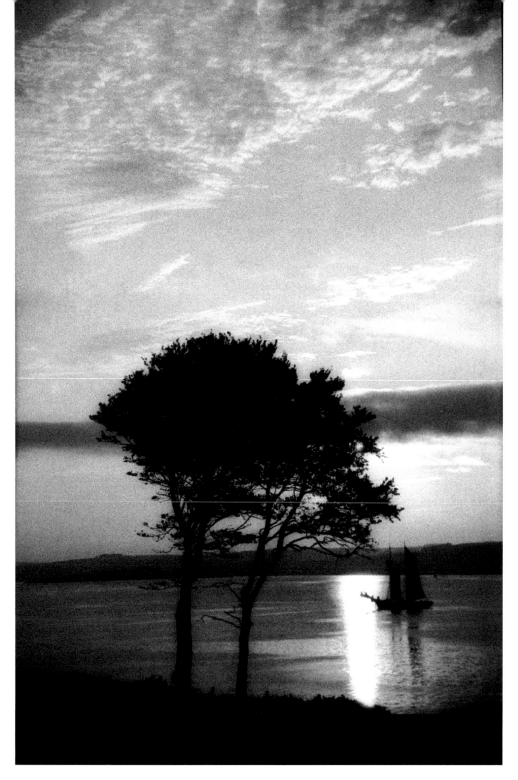

Sunset, County Cork (1930).

Index